david Ericson

Always Returning

The Life and Work of a Duluth Cultural Icon

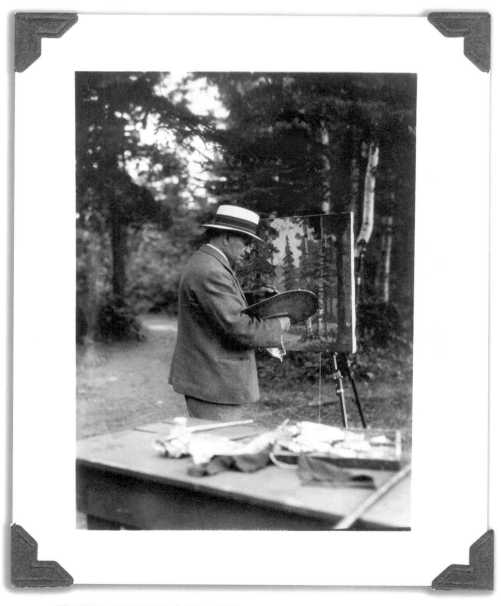

TWEED MUSEUM OF ART
University of Minnesota Duluth

DAVID ERICSON: ALWAYS RETURNING
THE LIFE AND WORK OF A DULUTH CULTURAL ICON

This catalogue is printed in an edition of 1,500 on the occasion of an exhibition at the
Tweed Museum of Art, University of Minnesota Duluth
August 28, 2005 – January 15, 2006

Catalogue design by Lisa Ryczkowski
Photography by Bruce Ojard, except pages 16, 86, 88, and 90 by Tom Lindstrom,
and page 78 by Patti Tolo

ISBN 1-889523-32-1

Tweed Museum of Art
University of Minnesota Duluth
1201 Ordean Court
Duluth, MN 55812
218.726.8222
fax 218.726.8503
tma@d.umn.edu
www.d.umn.edu/tma

This project is funded in part by the Alice Tweed Tuohy Foundation; the Minnesota
State Arts Board by an appropriation from the Minnesota Legislature and the National
Endowment for the Arts; and UMD Student Service Fees.

*This activity is made
possible in part by a grant
from the Minnesota State
Arts Board, through an
appropriation by the
Minnesota State
Legislature and a
grant from the National
Endowment for the Arts.*

MINNESOTA
STATE ARTS BOARD

Front Cover: *Winter Mists (Winter Scene, France)*, ca. 1925 – 1935
 oil on canvas, 51 ½" x 52"
 Collection of Robert M. and Mary Ellen Owens

Title Page: John H. Steele
 *David Ericson painting
 at Jay Cooke State Park*, ca. 1934

Back Cover: Photo of David Ericson
 painting in studio, ca. 1902

CONTENTS

CREDITS

MAJOR SUPPORT HAS COME FROM
Richard & Elizabeth Burns
Elizabeth Dudley
Mary M. Dwan
Fryberger, Buchanan, Smith & Frederick, P.A.
Beverly Goldfine
Raija Macheledt
Alice B. O'Connor
Robert M. & Mary Ellen Owens
Republic Bank
Anonymous Donor

ADDITIONAL PUBLICATION SUPPORT HAS COME FROM
Roger & Florence Collins; Esterbrooks, Scott, Signorelli, Peterson, Smithson, Ltd.; Guilford Lewis & Rondi Erickson; Charles & Carolyn Russell; Steven J. Seiler, Johnson, Killen & Seiler, P.A.; Peter & Sally Sneve; Patrick Spott & Kay Biga

THE FOLLOWING INDIVIDUALS ALSO LENT THEIR SUPPORT TO THIS PROJECT
Elliott Bayly & Anne Lewis; Steve & Kay Bloom; John Brickson; R. Craft & Eleanore M. Dryer; Kamal & Adu Gindy; Richard & Bea Levey; Frances McGiffert, John & Sandy Nys; Stuart & Robin Seiler; William & Kay Slack; Fred & Janet Schoeder; Dan Shogren & Susan Meyer

INTRODUCTION

We celebrate the memory of a man who began in poverty and rose to become a cultural icon in his native home. David Ericson, as an artist, bridges the fast-changing stylistic characterizations of turn of the century American and European art. To follow Ericson's career is to track the primary influences on the arts of his era. We also celebrate the artist for his own unique abilities both as an acute observer and versatile draftsman. Moreover, Ericson was an extraordinary and sensitive portraitist. Those who supported him throughout his career from an early age may or may not have been sophisticates but they recognized the artist's natural genius and were compelled to help this favorite son follow his gift wherever it would take him. Now, almost 60 years since his death, the name Ericson is legend and his paintings, held dear by so many people of the Northland, are given with confidence to the museum, or passed on to the next family generation with pride.

The Tweed Museum of Art, it's board, staff and friends wish to thank those whose contributions, art loans, labor and expertise made this program possible.

Scholarship was provided by J. Gray Sweeney & William Boyce, Thomas O'Sullivan, and Pat Maus. Personal recollections were provided by Frances McGiffert. We thank them all for the depth and professionalism of their contribution.

Exhibition and catalogue production, the very substance of what constitutes the making of such a program was comprised of the talents and skills of exhibition designer Arden Weaver, catalogue designer Lisa Ryczkowski, copy editor Bill Shipley, photographer Bruce Ojard, and interns Lindy Sexton and Sarah Stone. Thank you to their imagination, professionalism and strength of purpose.

Thank you to Beverly Goldfine and Henry Roberts who led the campaign to support this project by lending their names, enthusiasm, time, labor and address books. Thank you Minnesota State Arts Board, too, though embattled by budget scarcity the agency still provided operations support to the Tweed. For all these efforts and commitments, we are grateful.

I would like to thank those special persons who loaned artwork to the exhibition including Anne Aspoas, R. Craft and Eleanore Dryer, Duluth Public Library, City of Duluth, Glensheen Historic Estate, UMD, Beverly Goldfine, Joanne Halsey, Neal and Kathy Hesson, Margaret Jost, the Elizabeth Jeronimus Estate, Dan and Chris King, Kitchi Gammi Club, Duluth, Kevin Owens, Robert M. and Mary Ellen Owens, Dr. William Rudie, St. Louis County Historical Society, Duluth, Tiss Underdahl, and Anonymous Lender.

Major Financial support was contributed by Richard & Elizabeth Burns, Elizabeth Dudley, Mary M. Dwan, Fryberger, Buchanan, Smith & Frederick, P.A., Beverly Goldfine

Raija Macheledt, Alice B. O'Connor, Robert M. & Mary Ellen Owens, Republic Bank, and an Anonymous Donor. We thank them for their foundational contributions.

Program financial support was also provided by Roger & Florence Collins; Esterbrooks, Scott, Signorelli, Peterson, Smithson, Ltd.; Guilford Lewis & Rondi Erickson; Charles & Carolyn Russell; Steven J. Seiler, Johnson, Killen & Seiler, P.A.; Peter & Sally Sneve, and Patrick Spott & Kay Biga. We thank these contributors for their confidence in the project.

Additional financial support was contributed by Elliott Bayly & Anne Lewis; Steve & Kay Bloom; John Brickson; R. Craft & Eleanore M. Dryer; Kamal & Adu Gindy; Richard & Bea Levey; Frances McGiffert; John & Sandy Nys; Stuart & Robin Seiler; William & Kay Slack; Fred & Janet Schoeder, and Dan Shogren & Susan Meyer. We appreciate the thoughtfulness and generosity of these persons.

Last but never least, I wish to acknowledge and applaud Peter Spooner for his thorough, dogged, intelligent, persistent and well-focused effort to bring David Ericson to life, and to reveal to our community and region the importance of this courageous artist of Duluth.

Ken Bloom, Director

DAVID ERICSON: ALWAYS RETURNING
by Peter Spooner, Curator

LEAVING DULUTH - STUDY IN NEW YORK

When it was "arranged [by] his admirers" that Ericson go to New York to study art, he no doubt felt a degree of pressure and a personal obligation to succeed. Given his family's modest circumstances and the assistance received from wealthier Duluth patrons, critical and commercial success on a national, and at times an international level, was something he could give back to his hometown. Duluth, as a maritime frontier town on the nation's largest inland sea was in dire need of a cultural identity. "Minnesotans considered orchestras, museums, and schools worthwhile in themselves, and also saw them as proof, to fellow citizens and to the world at large, that civilization flourished there."[1] For Ericson, the need to please his hometown audiences and their conservative tastes, along with the pressure to pay his own way, may have steered him toward more traditional themes and styles in painting, and away from the experiments of his more avant-garde contemporaries.

Had he been born a generation earlier, Ericson would likely have fallen under the twin spells of naturalism (as advocated by John Ruskin) and the Barbizon school, as did other American painters who sought to combine realism with a poetic sensibility, without resorting to narrative and overly literal sentiment. One American artist Ericson knew, and another he admired, were identified with the French Barbizon School at key points in their careers. The details of Homer Dodge Martin's (1836 – 1897) life are remarkably like Ericson's, but twenty-five years prior. Originally working in the realistic style of the Hudson River School, Martin's paintings became looser and more simplified after he studied with Whistler in 1876. Like Ericson Martin had painted in Normandy and along America's eastern seacoast. Coincidentally, Martin moved to St. Paul in 1895 and died there in 1897, the same year that Ericson left Duluth for New York. A 1912 article stated:

> "Homer Martin, Ericson considers one of the greatest 'poets' in America. It is interesting to note that his [Ericson's] 'Winter in France' has been compared to some of Martin's work. The Barbizon group of artists he [Ericson] intensely admires as 'great poets in paint.' "[2]

To the young Minnesotan, New York must have been at once thrilling and daunting. He immersed himself in his studies, established a studio on East 23rd Street, and frequented the city's museums. This must have seemed like a treasure trove that suddenly opened to him. Ericson studied at the Art Students League between 1887 and 1890. His principal instructors – Kenyon Cox, Harry Mowbray and George Forest Brush – were relatively conservative academic painters, who also had careers as illustrators. He also studied with William Merritt Chase and James Carroll Beckwith, completed courses in modeling with Augustus Saint-Gaudens, and attended Thomas Eakins' lectures on anatomy. Judging from his figurative and genre paintings and his portraits in oil, pencil and conté crayon, Ericson absorbed fully, and was influenced by the academic training of the Art Students League. Before long, Ericson was producing illustrations for magazines such as *Life, Scribner's, The Century, St. Nicholas*, and *Youth's Companion*. Just seven or eight years earlier, these last two magazines had provided a bedridden Ericson distraction from his pain and illness. To further support himself, Ericson worked as an engraver for Tiffany & Co. Little documentation substantiates the movements of the artist during the decade following his years of study

at the League, but it can be assumed that he leap-frogged between New York and Duluth. Portraits of family members and his chief patron Charles Johnson date from the 1890s, as does his portrait of the writer Stephen Crane and an unlocated portrait of Nelly Crouse, Crane's "sweetheart" at the time. Ericson's reminiscence of the author, written at the request of Crane biographer Ames W. Williams in 1942, provides a delightful first-hand account:

> "About the year 1893 Steven Crane drifted into my studio in the old Needham building, East 23rd St. He was, at that time, writing *The Red Badge of Courage*. I remember one time when he was lying in a hammock of his saying 'That is great!' It shocked me for the moment. I thought how conceited he is. But when he read me the passage, I realized at once how wonderfully real it was, and said that the writer had that advantage over us painters in that he could make his men talk, walk and think. Whereas a painter can only depict a man in one position at a time. He seemed very pleased with this compliment. That was a week or so before I painted his sweetheart's portrait.[3]

Ericson wrote this three decades after Marcel Duchamp's *Nude Descending a Staircase* was exhibited at the 1913 Armory Show. One can't help but wonder if he realized the irony of his own words regarding a painter "only [depicting] a man in one position at a time."

In New York Ericson befriended the painter Edward Dufner, who was a fellow student at the League. Dufner's paintings were stylistically consistent compared to Ericson's, but his renditions of family groups in placid landscapes nonetheless share Ericson's interest in evocations of a quiet, romantic communion with nature. Ericson also knew the painter John Henry Twachtman, one of the most original American impressionists," whose snow scenes, with their carefully modulated tonal variations, provided a wintry parallel to Whistler's nocturnes. Ericson's own winter landscapes, such as *Winter Scene with Sheepherder* and *Fisherman's Cottages* (ca. 1915 – 24) are quite loosely painted, and seem to be modeled after Twachtman's.

Ericson's portraits, genre and figure paintings make up a large percentage of his life's work, and with few exceptions were produced in the first half of his career between 1890 and 1920. Early genre paintings like *Sheepherder* (1903), *The Sheik* (ca. 1900 –1910) and *The Spinner* (ca. 1903) share techniques common to traditional academic painting; careful modeling in monochrome, over which glazes of clear mediums carrying thin layers of other colors are brushed, over which highlights and small touches of stronger colors are applied. By 1910 Ericson had created a group of paintings that responded specifically to the tradition of northern Romantic painting and, as J. Gray Sweeney notes, to Albert Pinkham Ryder's dark, mystical works, which Ericson would have seen when he taught in Buffalo, New York in 1908 – 09. *Graveyard Sermon*, *Blue Landscape with Nymphs Dancing* (both ca. 1900 – 10), and the unusual painting *Night and Day*, are allegorical narratives from mythological sources. In honor of his mother, who died in 1905, Ericson produced an Ascension painting for Duluth's Gloria Dei Lutheran Church, which he modeled after a work by German romantic painter Heinrich Hofman.

As J. Gray Sweeney observed:

> "David Ericson would have become a greater artist had he remained true to the northern tradition out of which he emerged, rather than attempting to follow the movements of the French avant-garde. Yet his peregrinations of style and subject were entirely typical of many American artists of the period who were seeking a new foundation for their art – one responsive to the rapidly changing conditions that afflicted the art world with the advent of modernism."[4]

In 1903, David Ericson and Susan Barnard were married in Duluth. The couple settled in New York, where their only son, David Barnard Ericson, was born a year later. Susan was also an artist, and several letters indicate that the couple traveled and painted together. To Ericson's paintings in the northern Romantic vein, one should add those where his son is the subject, including *Morning of Life* (1907), *Boy with Toy Sailboat* (ca. 1910 – 12), and a large *Nativity* (ca. 1910 – 19). Paintings of his son, to whom he was extremely devoted, gave Ericson the opportunity to explore the allegorical themes of youth and life's journey. The sentiments surrounding fatherhood may have also inspired Ericson to see himself, as much as his son, as "the boy in the boat" and to reflect

on the difficulties of his own childhood. Ericson painted *The Artist's Son, France* (1910) in the sugary, sun-drenched impressionistic style of Frank W. Benson (1862 – 1951), once again proving his willingness to match style to scene.

WHISTLER, ERICSON'S MODERN

With income from his illustration work and the sale of paintings in New York and Duluth, Ericson made the first of at least six trips to Europe in 1900. He sought out James McNeill Whistler, and was admitted to the atelier Carmen Rossi (one of Whistler's models) that had been established in Paris in 1898. Whistler became Ericson's greatest model of "the modern" in art. As a proponent of the "art for art's sake" ideology of the aesthetic movement, Whistler's ideas attracted Ericson, whose own work began to move away from literal storytelling as it developed. In New York at the end of the 1880s, he could not have avoided the media buzz and art world gossip about the expatriate artist even if he had tried; the libel suit he brought (and won) against the English critic John Ruskin was front- page news. When John Ruskin referred to Whistler's *Nocturne in Black and Gold: The Falling Rocket* (Detroit Institute of Arts) as "a pot of paint" flung in the public's face, Whistler defended himself in the court proceedings, in effect creating a schism between painting and its subjects, more or less at the same time Impressionism opened up a space between images of things and the painterly languages used to describe them. In an article published on May 22, 1878 Whistler wrote:

"Take the picture of my mother, exhibited at the Royal Academy as an 'Arrangement in Grey and Black.' Now that is what it is. To me it is interesting as a picture of my mother; but what can or ought the public to care about the identity of the portrait? …Art should be independent of all clap-trap should stand alone, and appeal to the artistic sense of eye or ear, without confounding this with emotions entirely foreign to it, as devotion, pity, love, patriotism, and the like. All these have no kind of concern with it, and that is why I insist on calling my works 'arrangements' and 'harmonies.' "[5]

Ericson wrote an account of Whistler in a letter to Mrs. Frederic Paine (nee Emily Sargent), his first patron and teacher:

"Mr. Whistler is a fine instructor as well as painter. He criticizes once a week, and his presence is announced by the massier of the class, who takes his cane and high hat, and gives any necessary introductions. The students bow very low from the hips, the master pulls out his eye-glass, takes a look around, and enters with little bows to the right and left as he goes from easel to easel. We flock about his little figure hovering ourselves over him as to catch his precious words."

The letter goes on to detail a side trip, making it clear that he was "looking for paintings" along the way: "I took a short trip to Italy, not long ago… The ride through the mountains was a nocturne in silver and blue. The moonlight mountain-tops, and misty vallies (sic) made it a veritable fairy-land."[6]

On his first visit to France, Ericson studied with the sculptor Emmanuel Fremiet and with Rene-Francois Prinet, whose 1914 painting *La Tradition* was the most contemporary work

Rene-Francois Prinet (French, 1861 – 1946)
La Tradition, 1915
oil on canvas, 54" x 57 ¾"
Tweed Museum of Art
Gift of Alice Tweed Tuohy

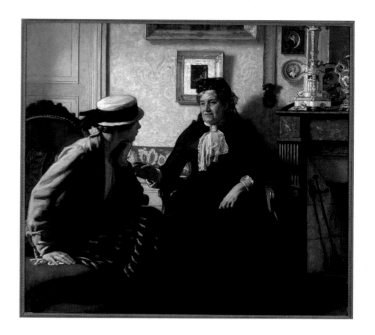

the conservative George Tweed collected, and one of few by a living artist. It is difficult to ascertain what, if any, influence Prinet had on Ericson, although elements of patterning and tapestry-like texture are seen in both *La Tradition* and in Ericson's *Woman in a Black Coat* and *By Lamplight* (1920). The dry, bristle-brushed surfaces of both paintings appear in several harbor scenes by Ericson as well, for example *Boujital sur Seine* (1938) *Fishing Boats at Rest*, both from 1938. As far as we know, Ericson painted only one interior (*Gorches*, ca. 1920s).

Untitled (Landscape with House), a newly discovered work dated 1914, is thickly painted in the manner of mature French Impressionism. One of the few still life subjects Ericson painted, *Fruit (Still Life)*, ca. 1915 – 25, shows Ericson experimenting with Matisse-inspired patterning, outlining and flattening of form. These works clearly demonstrate that Ericson experimented with formalist styles early in his career. The path he followed the longest and most often in his peripatetic career, however, was one laid out by Whistler and the aesthetic movement. Ericson's attraction to Whistler no doubt lay in the older artist's references to poetry and music, which allowed a meta-narrative into what others saw as almost complete abstraction. Whistler's titles alone – arrangements, symphonies, nocturnes – would have been enough to attract the romantically-inclined Ericson. Nature-based metaphors painted in a tonalist, Whistlerian palette were, in the end, Ericson's touchstones. Subjectivity was the hallmark of Ericson's time and of the aesthetic movement. It freed artists like John LaFarge, Henry Ossawa Tanner, Augustus Vincent Tack, Elihu Vedder, Thomas W. Dewing and Whistler himself, to "specialize" in order to distinguish themselves.

In her seminal work, *Inventing the Modern Artist*, Sarah Burns discusses an increasing specialization in artistic pursuits at the turn of the century, noting that it became increasingly important for artists to lay claim to subjects, places and stylistic approaches, in order to differentiate and market themselves, citing Charles Rollo Peters (1869 – 1928) as an example:

> "…obviously indebted to Whistler, [Peters] gave the nocturne his own local, personal stamp. …A Chicago critic wrote, 'This is the age of the specialist, and in every branch of work where deep research is required, it is the specialist who wins."[7]

In those terms, Ericson's "specialty" would be the nocturnal landscape, and in particular, the nocturnal sea- or harbor-scape. But even then, was he too broad in the inclusion of other styles and subjects into his larger oeuvre to adequately market his specialty? Ericson's critical success in newspaper articles did not necessarily translate into sales, and while some paintings were sold in Duluth, through exhibitions in Detroit and Minneapolis, and through the dealer and materials supplier Rene Lefebvre-Foinet in Paris, Ericson did struggle financially, especially around the World Wars, which both sent him packing home from Europe, in one case having to abandon paintings shipside.

In a rare bit of self promotion, Ericson challenged Duluthian George P. Tweed's practice of ignoring regional artists and collecting only "big names" through dealers in New York:

> "You are of course buying names but even in that, I can assure you that mine stands as high as the best. I knew Twachtman very well while a student in New York. I also knew Dufner very well for he was a student with me. I know that I get the big thing, the thing that makes pictures live. Other artists think so too, they have told me so. Some of the dealers admit it, but dealers are rarely sincere. They talk up the thing they want to sell."[8]

George Tweed was unmoved by Ericson's letter, and never purchased his work. However, his widow, Alice Tweed Tuohy and her daughter Bernice Brickson (who were instrumental in establishing the museum that bears his name) along with Alice's second husband Dr. Edward Tuohy and her brother Howard W. Lyon, all must have purchased

Ericson's work, since between them ten Ericson paintings were bequeathed to the collection, including *Morning of Life*, one of the museum's most universally popular Ericson canvases, and a wonderful group of oil sketches from Etaples, France. Elizabeth Congdon was another local collector and supporter of Ericson's work (as well as an aspiring artist). One of Ericson's last paintings *Tucson, Arizona Garden* (1943) is of her southwest home, and inscribed by Ericson to her. Along with Ericson paintings of *New Orleans* and *Brussels*, the *Tucson* painting joins the wonderful art collection amassed by her parents (whose portraits Ericson painted) at Glensheen Historic Estate.

Ericson's letter to Tweed was written on the same day an article appeared in the *Duluth News Tribune*, announcing a new exhibition of works he had produced in France. The writer gives Ericson a sort of backhanded compliment, and intentionally or not, highlights the reason that Ericson's paintings "played well" in Duluth: "Mr. Ericson always brings back with him something new. His compositions never offend, and his pictures represent careful planning, infinite care in execution and solid progress."[9]

Ericson would spend nearly twenty years, on six different trips, traveling and painting in Europe. He spent a great deal of time on the Normandy coast, especially in Etaples, painting the village, seacoast and surrounding landscape. Ericson painted on the Elb, a tributary of the Seine, where he produced *Winter Mists* (ca. 1925). One of his largest and most remarkable impressionist works is this snow scene that features the same poplars Monet had painted there. He also painted in Belgium, and in Italy, where the works he considered his greatest achievements were done in the 1930s. Ericson described these works in letters to his Duluth friend and student, Dr. Arthur Collins:

> "This time I realized Venice so much better than I did thirty years ago when I was a student. I have a scheme which I shall try when I get settled in our studio—of painting the ideas in blue and white and then glazing transparent colors over so as to produce a dreamlike quality."

The combination of glazes of color and thickly textured paint in these works does tend to produce a shimmering effect, which enhances their impressionistic qualities, and, at the same time preserves the architecture of the Venice landmarks in a kind of tonal drawing. The best of these late works, which was discovered only recently, is *Old Bridge, Chioggia* (ca. 1930s), Ericson's mannered blend of Monet and Whistler. Ericson assessed the results of his newfound technique positively, saying, "Today we took a look at my Venetian pictures.... ten rather large ones and a number of smaller ones. I have developed a personal style in these so that they are the most elegant in color and tonal qualities that I have ever done."[10]

Between 1934 and 1936, Ericson taught in Duluth, under the auspices of the Duluth Art Association (now the Duluth Art Institute). Mrs. Frances McGiffert, one of his painting students and a model for the 1935 painting *Circus*, graciously consented to be interviewed for this project and her account of Ericson and Duluth at early- to mid-century lends an all-too-rare first-person account to our study of the artist. When not in Duluth or in France,

which they both had come to love as a place to live and paint, David and Sue Ericson spent most of their time in Provincetown, Massachusetts, where they hosted artistic "salons" in their home. As strangely prophesied by his appearance at age three as "the boy in the boat," their son became a successful oceanic geologist, a researcher at the Lamont Geological Observatory who later taught at Columbia University. Susan Ericson had been ill periodically since the early 1930s, and was often unable to travel with her husband. She died in Provincetown in 1941.

David was heartbroken by Sue's death, and could not paint. Duluth friends convinced him to return home once more, which he did, in the summer of 1943. Ericson immersed himself in the practice and the business of art. He taught again for the Duluth Art Association, worked out of studios above Decker's Art Store and in Tweed Hall (part of the "Old Campus" of what is now UMD), and completed a large commission for the St. George Serbian Orthodox Church. At 77 years old, Ericson quipped to a *Duluth News Tribune* reporter, "Michelangelo and Titian both painted until they were about ninety. Death is the only retirement."[11] On December 5, 1946, while walking near Superior Street and 12th Avenue East, David Ericson was struck by a car. He died nine days later. The entire community mourned the loss of Ericson, who more than fulfilled his role as a cultural ambassador and icon.

Arthur Collins, Ericson's confidant at the end of his life, mused, "He loved art as he loved life... To him all the world was filled with beauty, either in design, color or atmospheric content. 'How elusive and mystical that is,' he would say and he would glory in a sunset or a cloud effect and discuss its possibilities in paint."[12] Homer Armstrong delivered an eloquent eulogy for the artist, which lent poignant insight into Ercson's artistic, and spiritual, process:

> "I asked him one day, in a friendly sort of way, just how he went about painting one of his North Shore scenes. 'Well,' he said 'Mr. Armstrong, before I begin to paint a particular scene I go out and spend a while in that locality. Sometimes I have gone up the North Shore and stopped for several days; long periods at a time; letting the trees, the sky and the water talk to me and prepare my soul for the picture. Great canvasses,' he said, 'are born here,' and with his hand he pointed to his breast. And so David Ericson painted his soul into his pictures."[13]

And so, as he told Mr. Tweed, David Ericson really did "get the big thing, the thing that makes pictures live."

[1] Thomas O'Sullivan, "Robert Koehler and Painting in Minnesota ," in *Art and Life on the Upper Mississippi*, 1890-1915, Michael Conforti, ed., Newark: University of Delaware Press, and London and Toronto: Associated University Presses, 1994, pp. 95-96.

[2] "Work of Minnesota Artist, David Ericson, Who Enjoys an International Reputation," *The Minneapolis Sunday Tribune*, March 3, 1912, p. 24.

[3] Letter from David Ericson in Provincetown, Massachusetts, to Crane biographer Ames W. Williams, November 4, 1942. Ericson archive, Tweed Museum of Art, University of Minnesota Duluth. Ericson's reminiscence of Crane is published in *Stephen Crane Remembered*, University of Alabama Press in 2006, authored by Paul Sorrentino. His portrait of Crane is featured as the book's cover illustration.

[4] J. Gray Sweeney, *American Painting: Tweed Museum of Art*, Duluth: University of Minnesota, 1982, pp. 188-189.

[5] James McNeill Whistler, *The World*, London, May 22, 1878, in Robin Spencer, *Whistler: The Masterworks*, New York: Portland House, 1990

[6] Excerpts from letter from David Ericson in Paris, to Mrs. F. W. Paine (formerly Emily Sargent) in Duluth, 1901.

[7] Sarah Burns, Inventing the Modern Artist: Art and Culture in Gilded Age America, London and New Haven: Yale University Press, 1996, p. 122-125.

[8] Letter from David Ericson to George P. Tweed, December 15, 1924, in J. Gray Sweeney, *American Painting: Tweed Museum of Art*, Duluth: University of Minnesota, 1982, p. 200.

[9] "Mrs. McKindley receives from France works of David Ericson," *Duluth News Tribune*, December 15, 1924.

[10] Excerpt from a letter from David Ericson to Dr. Arthur N. Collins in November, 1931, in William Boyce, *David Ericson* , Duluth, MN: Tweed Museum of Art, 1963, pp. 20-22.

[11] In J. Gray Sweeney, *American Painting: Tweed Museum of Art*, Duluth: University of Minnesota, 1982, p. 196.

[12] Excerpt from a letter from Dr. Arthur N. Collins of Duluth addressed to the St Louis County Historical Society, following Ericson's death, January 3, 1946 Ericson archive, Tweed Museum of Art, University of Minnesota Duluth.

[13] Excerpt from a memorial talk given at Gloria Dei Lutheran Church, Duluth on December 21, 1946, by Homer J. Armstrong, Minister, Judson Church, Minneapolis. Ericson archive, Tweed Museum of Art, University of Minnesota Duluth.

PORTRAIT PROFILES
by Patricia Maus

EUGENE F. W. (FREDERIC WILLIAM) PAINE, 1937
oil on canvas, 36" x 32"
Collection of Kitchi Gammi Club, Duluth

Frederic William Paine's 1940 death at age 83 was front page headline news in Duluth. In 1928 he was inducted into Duluth's Hall of Fame, just the fourth person so honored to that date. His community contributions were described as compelled by an interest in public welfare and charitable work. He was also specifically cited for his work in the Community Fund that he helped to found in 1921 — which is the present-day United Way. For more than 50 years he served Duluth on the park board, board of education, the Duluth Symphony Association, St. Paul's Episcopal Church, of which he was a warden and treasurer, and St. Luke's Hospital. In 1930 Mayor Samuel F. Snively asked him to undertake a relief program that resulted in the first unemployment commission formed in the early days of the Depression. When the city was unable to divert resources to administer the program, Paine, as the chairman, was a willing contributor toward its financing. His obituary states he served "innumerable" welfare and charitable societies. Frederic Paine preferred to be the anonymous patron of civic functions. He was born in Niles, Michigan in 1856. After his local education, he entered a law firm at Grand Rapids, Michigan where he remained until he moved to Duluth in 1880, to care for the interests of Omar H. Simonds, a member of the firm. He started the Duluth National Bank in 1882, and the Paine & Lardner banking house five years later. (Henry Lardner was the father of the noted writer and humorist Ring Lardner.) Paine left banking in 1896 for the insurance field and several years later devoted his time to private interests. He married Emilie Sargent with whom he had two children, Mary Welles and Frederic Rodney Paine.

EMILIE SARGENT PAINE
SUPERIOR STREET, (DETAIL), 1882
watercolor on paper, 5" x12"
Collection of St. Louis County Historical Society, Duluth

Emilie Macklot Sargent Paine was the daughter of New England parents Mary Perin and General George Barnard Sargent. The general first came to Duluth in 1852 and George returned with Mary in 1869 when George was the representative of Jay Cooke and Company. Emilie's parents married in Iowa in 1836; they had ten children. Only Emilie and one brother, William Coffin (born 1859, the youngest Sargent child) were living in 1890. Emilie's parents lived in such dissimilar places as Davenport, Iowa and New York City. William was born in Boston. Emilie grew up in the family's Duluth home on London Road, built in 1872, which they owned until 1897. Emilie married Frederic William Paine, and they were the parents of four children, (two lived to adulthood) Mary Welles Paine and Frederic Rodney Paine. Emilie and Frederic lived at 1007 London Road. He was a lawyer, an insurance agent, later an investment banker (Paine & Lardner) and land investor. Their summer home, called Sunrise Terrace, a log cabin with fireplaces, was built on a 95 acre site by Emilie and Frederic on the Paine Farm Road with an entrance near Amity Creek. As members of the St. Paul's Episcopal Church, they watched the construction of their new church building designed by architect Bertram Goodhue — who was also the architect of the Kitchi Gammi Club, Hartley residence and Hartley office buildings

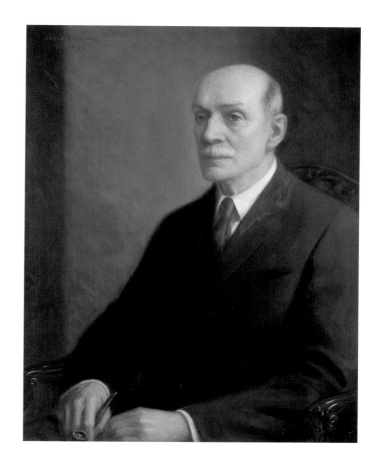

in Duluth. They engaged Goodhue to design an English stone farm cottage and barn on their property near the log cabin. Sunrise Terrace became the Paine Farm. The property was operated as a farm until after WWII. Their son, F. Rodney Paine, superintendent of the Duluth parks department, maintained the farm raising vegetables, raspberries, apples and evergreens until his death in 1968. Emilie and Frederic were local philanthropists supporting Duluth hospitals and charities. They were the first contributors to the Duluth Symphony when its organization in 1928 was announced. They also orchestrated less visible deeds like loaning their Packard and chauffeur to drive interested citizens — including John Darling — to and from a history meeting in Mountain Iron, Minnesota in 1929. Emilie Paine was born in Davenport, Iowa November 8, 1855 and died in Duluth two years after her husband in 1942, one year before her brother.

MRS. EMELINE JOHNSON HILTON, ca. 1910 –1915
oil on canvas
(location unknown)

Emeline L. Johnson, the only daughter of Charles F. and Mary S. Johnson, claimed the distinction of being the first woman in the United States to hold the occupation of Customs & Drawback Broker, a position she inherited from her father. She began that work in 1890, the year she graduated from high school. She held the post until 1906, working in two rooms at the rear of the Exchange Building's top story in downtown Duluth. Emeline Louise was born in Duluth in her parent's living quarters over their bookshop in 1873 and given the names of her two grandmothers. She went to business college in 1900. Emeline was devoted to two decades-long pursuits: the task of publishing her father's Civil War reminiscences and the challenge of proving a 17th century portrait she possessed as an authentic work of the Flemish master portraitist Anthony Van Dyke. One of the two tasks was achieved. Her father's Civil War diaries became the book *The Long Roll* and featured pencil sketches by its author, with David Ericson contributing a number of sketches including a boyish portrait of Charles Johnson. Emeline's older brother made a design for the title page of the volume, the book was dedicated "to the soldier's grandson, George Robert Hilton", and Emeline wrote the introduction. Emeline Johnson and David Ericson were lifelong friends with numerous mutual acquaintances including Emeline's dog, Snap, an Irish Setter captured in two formal photographic portraits and many additional family photos. Emeline Johnson married Afton B. Hilton, a bank cashier from Fergus Falls, Minnesota in 1908. The couple had one child, a son, born in 1909. Mrs. Hilton said she owned four photographic studios, but it is unclear where they were located. The Hilton's son was a professor who died unexpectedly in 1955, at age 46, while head of the literature department at Coe College, Cedar Rapids, Iowa, leaving a wife and very young daughters. Emeline's obituary — which she assuredly wrote and updated regularly — said "she engaged in extensive correspondence with government officials whenever she felt there was cause to praise or question their work." She died in Duluth at age 85 in the autumn of 1958.

CHARLES FREDERICK JOHNSON, 1896
oil on canvas on board, 8" x 6"
Collection of St. Louis County
Historical Society, Duluth

Charles Frederick Johnson was born in Gisnabo, Sweden in 1843. He arrived in Richmond, Virginia as a boy of ten. He married Mary Susan Sherry in St. Paul, Minnesota in 1869. The couple made the arduous trek to Duluth in March of 1870, first by railroad to its terminus at Hinckley, Minnesota followed by two days of stagecoach transportation to Superior, Wisconsin. The next day, Charles rode the stage across the ice of the bay to Minnesota Point. Duluth was a struggling community of about 3,000 people. Years later, in 1895, Charles described his 1870 arrival: "...I strayed into Peter Dean's general merchandise store...and was snapped up unceremoniously to run the business for six weeks [while Dean traveled for additional inventory]... what little I knew about a business was entirely circumscribed by the term 'Books and Stationery'..." The Johnson's belongings

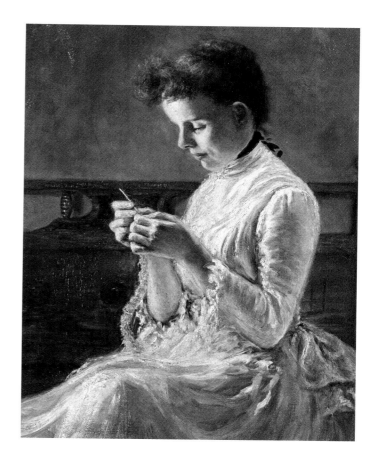

finally arrived two months later. They became parents of two children, Frederick (1870) and Emeline (1873). Charles and Mary were credited with establishing the first free circulating library in nascent Duluth their first year in town. Charles also established The Pioneer Bookstore, Duluth's first bookstore at 14 West Superior Street which subsequently became a partnership. Johnson & Evans was a printers, bookbinders, books, stationery, toys and notions firm that dated from at least 1882. Johnson published a daily circular of transactions of the board of trade titled "Duluth Daily Market Report", and a weekly journal devoted to mercantile and manufacturing interests and development of the Northwest titled "Journal of Commerce". But Johnson's daughter characterized her father as an artist, playwright and book dealer, deliberately ranking the descriptive words she selected. Charles left the bookstore to serve as Collector of Customs in 1889. The Johnson family lived at 120 Fourth Avenue West for 20 years, and it was there that Charles died February 8, 1896 at age 52. Charles' wife and daughter were responsible for the posthumous (1911) publishing of Charles' journal *The Long Roll* comprised of Johnson's Civil War experiences in the Hawkins Zouaves regiment of New York. Archived Johnson family papers include photographs of Charles, Mary and Emeline camping in the woods, Charles with a sketchbook in hand. Sketches by both Charles and his daughter survive.

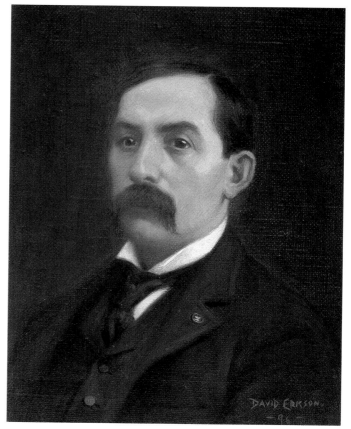

GLADYS H. CONGALTON, 1926
oil on canvas, 30" x 28"
Tweed Museum of Art
Gift of Mrs. Gladys Congalton

Little is known of Gladys Congalton. She was born in Duluth in 1891 as Gladys Mary Elliott. Her father, Jones Hall Elliott, was born in Canada but resided in Duluth for 60 years. He was foreman for the Scott-Graff lumber company for many years until 1938. Gladys' Danish mother, Minnie Christopher, died in 1929. Gladys had an older brother, Francis Bertram Elliott (Frank) who lived in British Columbia, Canada at the time of their father's death in 1943. Gladys was a music teacher in her home for several years including 1912 and 1913. She married at age 21, but divorced James M. Congalton in 1916. They had no children. She may have attended a business school or sought out courses in business in 1917 because a year later she was doing work with a specialized office machine called a comptometer, an adding machine of 1918. At the time of her portrait in 1926, she was 35 years of age. At the time of her death at age 78 in the Moose Lake State Hospital's geriatric care unit in 1969, she was described as a home-maker. Prior to her hospital care, from about 1965, she had resided at the Mae Morrow Home in Duluth which evolved into a unit of the Chris Jensen Health and Rehabilitation Center facility.

LEONIDAS MERRITT, ca. 1923
oil on canvas, 32" x 25"
Collection of Hibbing High School, Minnesota

Leonidas Merritt, Lon to family and friends, was the sixth of ten children born to Lewis and Hepzibah Merritt, early settlers of the West Duluth (Lincoln Park) neighborhood called Oneota. He was born on a farm in Chautauqua County, New York, arrived in Duluth as a 12-year-old boy in 1856, and educated in the small settlement schools at the head of the lakes. His name is synonymous with exploration, discovery, and early development of the iron ore industry of Minnesota achieved primarily with his two brothers Alfred and Cassius and their nephew John. The newspaper headline of May 1926 read: MOST COLORFUL FIGURE IN CITY'S HISTORY CALLED. His obituary was lengthy. Tributes followed in subsequent newspapers for many days and for decades afterward on anniversary dates that noted important Mesabi iron range mining or northern Minnesota railroad history. He was described as "...a mining genius, railroad builder, civic leader, and the oldest Duluthian in point of residence" at his death. His public service began at 18 in Company B of the Minnesota Cavalry and Brackett's Civil War Battalion in the Dakotas – he walked from Duluth to St. Paul to volunteer. He served a term in the Minnesota House of Representatives, was first president of the West Duluth Board of Trustees, a Duluth city commissioner of public utilities and later of finance, and a governor appointed him to the board of the Minnesota Old Soldiers Home. His legislative and commission work were important factors in placing the Minnesota ore fields in their commanding position as the world's largest. Leonidas Merritt donated Merritt Memorial Park and Playground to the Duluth parks system in honor of his clergyman brother Lucien: Merritt Elementary School was named for another brother, a teacher, Jerome. Leonidas married in 1873 when he was 29 to the girl he had grown-up with,

Anna Elizabeth E. Wheeler. Together Lon and Lizzie reared their three children, Ruth, Lucien, and Harry, to young adulthood in Duluth. Elizabeth died in 1902 at age 51. In 1904 Leonidas married Annice Cordelia Richardson Sprague, but Lon found himself a widower a second time when Cordelia died in 1910 just six years after their wedding. Lon Merritt lived until age 82, remaining active in business and civic affairs despite his advanced age. In later years, he spent time in Florida, but throughout his life his summer home at Pike Lake was pivotal. Pike Lake had always been a delightful gathering place for extended family. Lon died suddenly at home on an early Sunday morning in May of 1926 following a heart attack. Leonidas Merritt was buried in Duluth's Oneota Cemetery among many family members, and that is where his beloved younger brother and staunch supporter, Alf, would join him six months later.

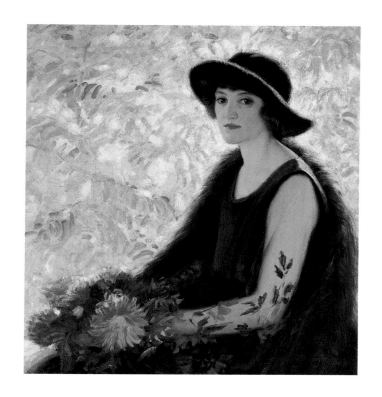

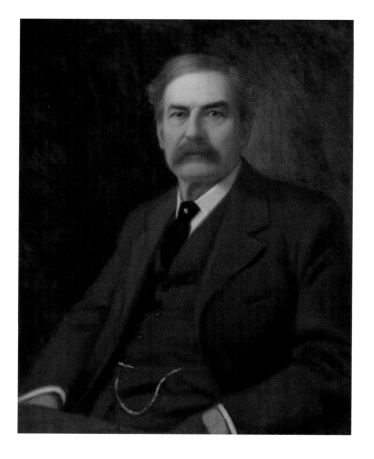

JOHN H. DARLING, 1935
oil on canvas, 34" x 26"
Tweed Museum of Art

John Henry Darling graduated with an engineering degree from the University of Michigan in 1873. He was born at Lake Ridge, Michigan, April 15, 1847. He married Addie Ford in 1880 and they came to Duluth in 1884 for John to be employed as principal U. S. assistant engineer on harbor improvements having spent the prior nine years working on the measurement of the primary triangulation that formed the basis for navigational charts of the Great Lakes. Darling was responsible for the design and construction of the breakwaters, entrance piers, channels and other navigational improvements in Lake Superior. While in public he would always be in a suit, vest, and hat, always bespectacled and wearing a well trimmed mustache and beard. Darling's leisure time with friends on a small yacht VIDETTE or on the rocks of the North Shore of Lake Superior was captured in photographs but he was never seen with a smile on his face. To pursue travel, scientific studies, and his avocation of astronomy, John Darling voluntarily retired from government service in 1913. His alma mater conferred a doctor of engineering degree upon him in 1915. In 1917, as a gift to Duluth, he spent $12,000 to design and build an observatory downtown for the interested public. The observatory, at 9th Avenue West and Third Street, was always free of charge. At another personal cost of $3,500 Darling bought and built the telescope housed there. Purchasing the required large lens for the telescope during war time required two attempts before he was successful. His spouse of forty years, Addie A. Ford of Tecumseh, Michigan, died in 1920. The couple had no children. John Darling was elected to Duluth's Hall of Fame in 1930, and died at age 95 in 1942. His will gave the observatory to the Duluth State Teachers College (UMD's predecessor institution) with an additional $20,000 trust fund for the observatory's upkeep. His nine-inch refractive telescope is located today in the lobby of UMD's Alworth Planetarium.

EUGENE WILLIAM BOHANNON, 1936
oil on canvas, 36" x 30"
Tweed Museum of Art

At the age of 35, Dr. E. William Bohannon took office as the first president of the Duluth Normal School on September 2, 1901, at an annual salary of $2,500, surpassing twenty rival candidates for the post. He married Mary Agnes Carny the same year. He had spent the prior three years at the Mankato Normal school. Mr. Bohannon was educated at the University of Indiana and awarded his doctor of philosophy from Clark University at Worcester, Massachusetts. He stayed with the Duluth Normal School until he retired on January 1, 1938, seeing it through the transition from a normal school to the Duluth State Teachers College. He had gained stature as a defender of educational excellence and of teachers specifically. Dr. Bohannon once stated that if people who "serve as teachers have not the character to remain free and uncontrolled in their thinking and acting, they have no right to be teaching." A biographer of Bohannon said he urged teachers to focus on their students and subject disciplines without becoming method-ridden. President Bohannon achieved crucial support for higher education through building alliances and relationships. Notable local residents who were fellow champions of education

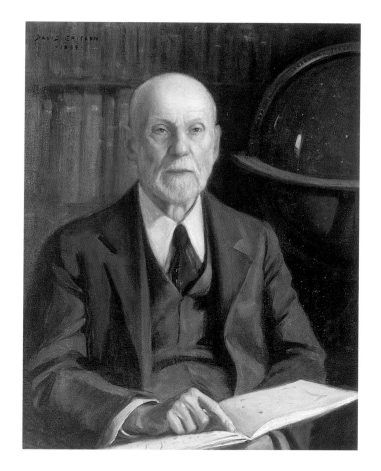

embraced Bohannon's goals and at Bohannon's urging they carried his message further and deeper into the community. As a result, philanthropist and long-time school board member Jed Washburn, author, writer (and Bohannon's former student) Margaret Culkin Banning, banker Stephen Kirby, businessman and later University of Minnesota Regent Richard L. Griggs, made notable contributions to education and many were made specifically to UMD. Each of these local leaders continued their relationships with Bohannon's UMD successors. Dr. Bohannon lived to see the name and organization of the college changed to the University of Minnesota, Duluth Branch in 1947 and UMD was formally established as a coordinate campus of the University of Minnesota. Gardening was his loved pastime, and there was a blueberry bog in his backyard just east of Old Main on Fifth Street. Dr. Bohannon died in 1955 at age 89 in Duluth.

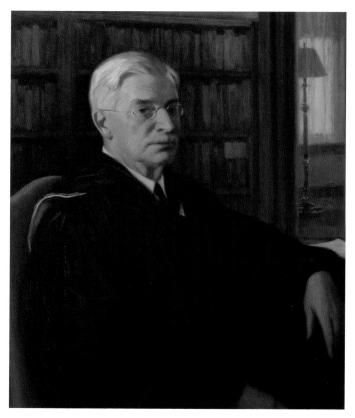

MRS. MARCUS L. FAY, ca. 1911
oil on canvas, 36 ¾" x 27"
Tweed Museum of Art
Gift of Ralph H. Schulze

Sarah Johanna Griffiths was born in 1848 at New Brunswick, Canada. She was brought to the United States by her English father who then served as an aide to General Ulysses S. Grant. Sarah married Marcus L. Fay in Manistee, Michigan, and they moved on to Wisconsin briefly. Their children, Clara and George, were both born in Virginia, Minnesota where Sarah and Marcus lived from 1894 until they moved to Duluth in 1907. As a member of Trinity Episcopal Cathedral, she supported several families in need. Sarah Griffiths Fay and another Sarah of Duluth, Sarah Burger Stearns, were zealous laborers in early social service focusing their mutual attention primarily on the founding and development of the Children's Home Society of Duluth — an organization also supported by Mr. F. W. Paine, Mr. W. C. Sargent, and later, Mrs. E. W. Bohannon. Sarah Fay served on the Home's board and maintained one of its rooms. Her unusually full-sized obituary, complete with a portrait photograph, warmly lauded her as a prominent charity worker whose loss from this needed work in Duluth was termed severe. She died at age 71 in Duluth on November 27, 1919, two years prior to her husband of 49 years. She was buried in Virginia, Minnesota near her husband.

MARCUS L. FAY, 1911
oil on canvas, 36 ¾" x 27"
Tweed Museum of Art
Gift of Ralph H. Schulze

Marcus Lafayette Fay, born in 1848, was a native of Woodstock, Ontario, Canada. He came to the rich woods of Michigan at age twenty. At 23, in Manistee, Michigan, he married Sarah J. Griffiths, who was born at New Brunswick, Canada. His arrival in Minnesota was delayed until he was 45, and yet he became a prominent explorer in the Lake Superior region and an early explorer on the Mesabi iron range visiting it initially in 1892. His iron ore dealings in later years were confined to the Cuyuna range in Crow Wing County Minnesota. He is credited with discovering nine Mesabi mines including the Alpena, Minorca (Fay), Chisholm, and the Kellogg. Fay resided for many years in the "Queen City" (Virginia, Minnesota) and served as its mayor. It was he who led the rebuilding of Virginia in brick block structures after the 1900 fire decimated the community of its wood frame buildings. The Fay Hotel, Fay Opera House and the Fay Block were all erected by him. He also built many cottages for Virginia's working families. A prominent Democrat, in 1902 he was nominated for Congress from the 8th District of Minnesota. At that time, Virginia and the area was ardently Republican. Although he lost, his support was the largest ever given to a democratic candidate. In the fall of 1903 he was elected-mayor of Virginia serving from 1904-1906. His extant campaign card avowed: "THE GANG IS IN THE SADDLE! The Breweries and some Saloons that they control, tin-horns, grafters and all others who profit by vice or violation of the laws are united. They aim to capture the whole commission. Will you stand with them or JOIN WITH ME FOR A Clean and Honest Government." He was targeted while he served as mayor: his home was partially demolished, the barn burned, and two horses died when someone

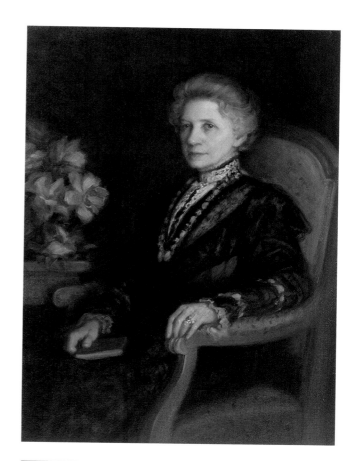

dynamited his property because "he enforced the laws." Nevertheless, he stayed and added a new city hall in 1906 and negotiated successfully for the Carnegie Library Fund. After his defeat for re-election as mayor, he relocated to Duluth in 1907. He divested most of his Mesabi range properties to pursue copper mine development in Sonora, Mexico. His Fay-Cananea Copper Company was capitalized at $3,000,000. He was a Duluth mayoral candidate in 1913. In 1921 he died of a heart attack in his Superior Street home at age 73, but was buried in Virginia, Minnesota. Marcus Fay was survived by a son, George of Crosby, Minnesota, and a daughter, Mrs. W. J. Schulze of Virginia.

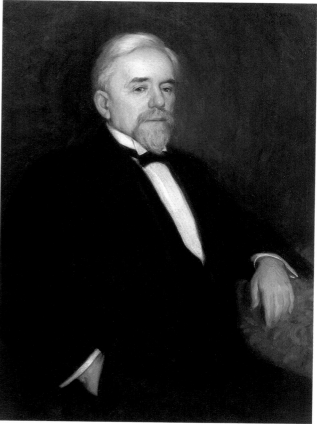

MARIA VAUGHAN (MRS. CHARLES COTTON) SALTER, 1918
conté crayon on paper, 17" x 12"
Tweed Museum of Art
Gift of the Estate of Julia Romano

Maria Vaughan was reared in Providence, Rhode Island where she was born in 1836 to Harriet Sprague and Christopher Vaughan. Nothing is known of her early life or education. She married in 1859, moving on to Kewaunee, Illinois when her husband, Reverend Dr. Charles Cotton Salter, took the pulpit of its First Congregational Church. She was described by a Northern Illinois parishioner as beautiful. Husband and wife were separated when he served as a chaplain with the 13th Connecticut Regiment in the Civil War from March to August 1862. The Salters lived wherever he was called to a church including Missouri, Illinois, and Denver. They arrived in Minneapolis in October of 1862, remaining there seven years. Separations were the norm for the couple as Charles was affected by on-going poor health which resulted in frequent relocations from 1861 through 1887. At one point, he traveled to Egypt and the Holy Lands remaining abroad for two years. Another breakdown took him abroad again, and yet again when he spent a year in Italy. It is not clear if Maria accompanied him, visited him, or consistently remained behind with their five children. Maria came to Duluth in 1871, when Dr. Salter became the first reverend of Pilgrim Congregational Church. Maria Salter was one of 16 charter members of the Pilgrim congregation. Maria's husband founded the Duluth Bethel and the YMCA: Maria was also known as a devoted church worker. They were much admired and loved in Duluth: Salter school was named for the clergyman. Four of their five children lived in Duluth: Dr. William H., Frank I., Mary Josephine (Ohio), Charles Cotton, Jr., and Julia. Maria was widowed in 1897, when her youngest child was15 years old. Maria lived on in Duluth and died of cancer in her Woodland home March 24, 1923 at the age of 87. She is buried in Duluth, her home of 52 years, at Forest Hill Cemetery.

CLARA STOCKER, 1927
conté crayon on paper, 21 ⅞" x 17 ⅜"
Collection of St. Louis County Historical Society

Clara M. Stocker (1888-1976) was a musician, composer, performer, linguist, and educator whose home was Duluth from her birth until 1952. She was the only daughter of physician Samuel Marston Stocker and Stella Prince who were married at Jacksonville, Illinois in 1885, and came to Duluth that year. Clara's mother was a formidable figure and influence upon Clara. Clara's mother was a composer and musical director who lectured in America and Europe on multiple topics ranging from Wagner's operas to American Indian myths and music. Clara's mother founded organizations still active in Duluth, the Duluth Cecilian Chorale Society, the precursor of the Matinee Musicale, and the Cecilian Society, a club for music study, that she began organizing in 1887. Clara traveled with her mother and slightly older brother, Arthur, a boy soprano. The threesome lived in New York City for a time when Stella lectured for the New York City Board of Education. The three also made several trips abroad. Most of 1900 and 1901 were spent in Germany and New York where Stella presented recital-lectures with Arthur performing. France was pivotal to Clara's education and this was noted by her mother in a review of the Paris music season that was published in Duluth's July 1908 newspaper. As a young woman, Clara taught

French and music from the Duluth home of her parents. In 1920 she received the Certificate d'Etudes Francaise from the University of Grenoble that allowed her to matriculate at the Sorbonne. She completed graduate work at Columbia University with subsequent courses in Gregorian Chant at Pius X School of Liturgical Music in New York City. Clara founded a Duluth chapter of the l'Alliance Francaise, serving as president in 1922-23. The organization brought prominent French lecturers to Duluth. Clara's personal Duluth contributions were in the field of music education. She composed for piano, flute and piano, violin and piano, wrote and arranged songs and put selected poems of James Joyce to music. Her teaching technique utilized folk songs which she drew from Scandinavian, French, Estonian, and Jewish cultures. She also wrote songs for the recorder, an instrument she played and taught. While she lectured on musical and literary subjects she said herself that her specialty was the arts of Finland. In addition to French, she was fluent in Finnish, and she had a long association with the Finnish painter Juho Rissanen who lived in Finland. Clara was music critic for Duluth's newspapers (1920s-1942) and wrote program notes for the Duluth Symphony Orchestra in the 1940s. She was a prolific writer in the field of music education. Four articles including "Teaching French Through Folk Songs" and "A Further Study in French Tonetics" were circulated, the latter and other pieces were published in *The Modern Language Journal* of 1920, 1924-1928. Her brother died as a youth; Clara's mother died in 1925, her father in 1929. At an advanced age, she moved to Florida and lived her last years in North Carolina, dying in Asheville in 1976. She did not marry. Clara Stocker is buried at Forest Hill Cemetery in Duluth.

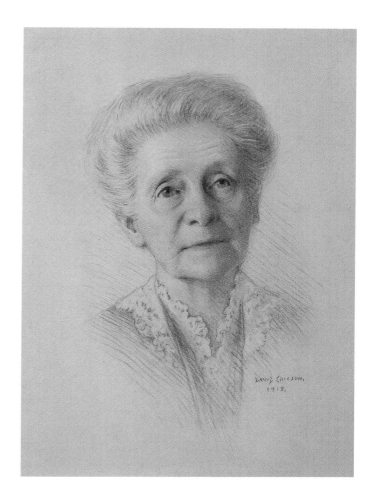

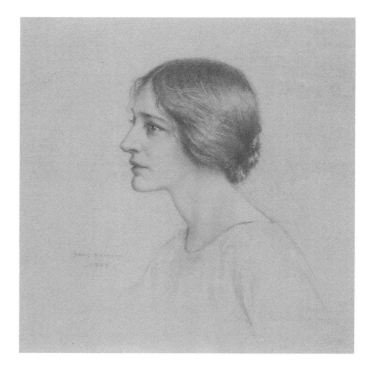

CHESTER A. CONGDON, ca. 1904
oil on canvas 28" x 22"
CLARA B. CONGDON, 1907
oil on canvas, 32" x 31"
Collection of Glensheen Historic Estate
University of Minnesota Duluth

Clara Hesperia Bannister and Chester Adgate Congdon were both children of Methodist clergymen, and both graduated from the first four-year class of Syracuse University in 1875. She was born in San Francisco, he in Rochester, New York.

Chester taught school for a year, but after being admitted to the New York bar in 1877 and Minnesota's bar in 1880, he practiced law in St. Paul from 1880 until 1892. He moved to Duluth in May, 1892, and continued at Billson & Congdon until he retired in 1904 to pursue other business enterprises. Chester was general counsel to the Oliver Iron Mining Company, president of several iron mining companies, vice president of the American Exchange National Bank of Duluth and director in many mining, smelting, paper and ore corporations. Chester Congdon served as Assistant U. S. Attorney, District of Minnesota from 1881-1886, and was a member of the Minnesota House of Representatives 1909 and 1911 sessions.

Clara married Chester in Syracuse in 1881. The couple had seven children: Walter, Edward, Marjorie, Helen, John(1891-1893), Elisabeth, and Robert. She was preceptor at Alexandria College, Belleville, Ontario from 1876-1878, and then taught art and modern languages for three years in Pennsylvania.

Chester founded the Congdon family business enterprises that brought them nationwide fame and played a big part in building the Duluth area.

They gave liberally to Duluth, and many places bear their name such as Congdon Park, Congdon Boulevard and Congdon School. Their home, built between 1905 and 1908, has long been a landmark in the area, and placed on the National Register of Historic Places in 1991.

Chester died enroute on a November business trip in 1916. Clara and a number of their children were at hand for his unexpected death at age 63 in a St. Paul hotel where illness had forced him to stay for the prior two weeks. Newspapers immediately chronicled his political career in detail; a succinct excerpt said: "although of the distinctly conservative type, he has been a Progressive, and entirely opposed to the old machine which for so many years held his party in thrall." His election as national committeeman of the party in Minnesota at Chicago last June [1915] was looked upon as a triumph of the progressive branch of that party, and much was expected of his influence in shaping the affairs of the party in the next four years. Mr. Congdon was actuated by the highest and most unselfish motives in his entrance into civic, state, and national affairs. He was far from self-seeking — rather the opposite."

It is impossible to say how Duluth might have benefited additionally from the largesse of the Congdons had Chester lived on. An opinion piece about Congdon Boulevard by

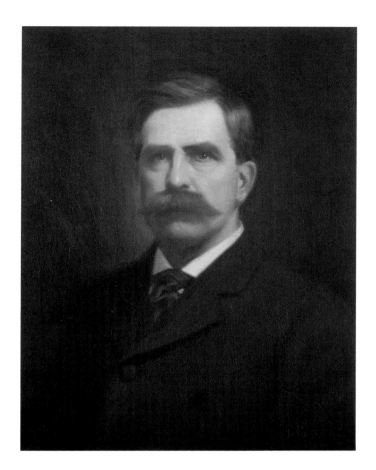

Judge Clarence Magney published in the *Duluth Herald* in 1935 was headed by the words "Arrowhead's Debt to Congdon Family" and confirmed that the people of Duluth wanted to honor Chester and Clara "whose foresight and generosity made possible this magnificent lake shore drive."

Clara lived 34 years in Duluth after her husband's death. She died at age 96 in 1950 at their home, Glensheen, then referred to only by its street address — 3300 London Road. Clara's estate was confirmed in the press as well over three million dollars (equal to more than 24 million dollars today). She was called a leader in humanitarian, civic and educational causes. She was a benefactor of Syracuse University, establishing a professorship in public law in honor of Chester in 1936. Chester had served on its board of trustees for many years. Glensheen, the 22 acre historic estate with 39 room house, was given to UMD in 1968 by the heirs of Chester and Clara Congdon. The estate opened for public tours in 1979. Clara and Chester are buried in Duluth's Forest Hill Cemetery.

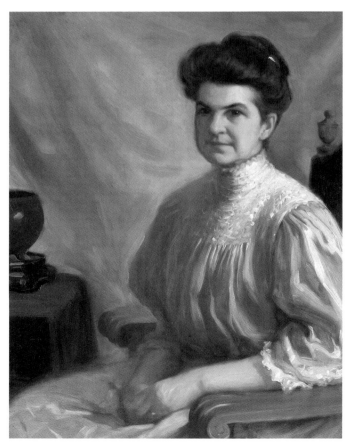

SUPERIOR STREET, 1882
watercolor on paper, 5" x 12"
Collection of St. Louis County
Historical Society, Duluth

SPIRIT LAKE, ca. 1880s
watercolor on paper, 8" x 13"
Collection of Neal and Kathy Hesson

MARSHLAND, 1898
watercolor on paper, 6 ⅜" x 10"
Tweed Museum of Art
Gift of Miss Virginia McDonald

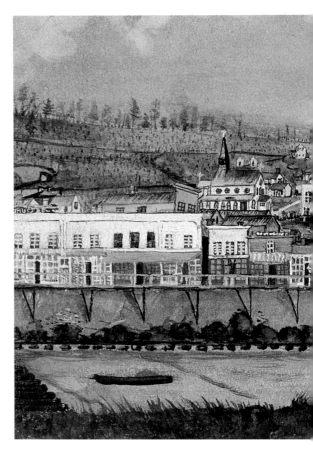

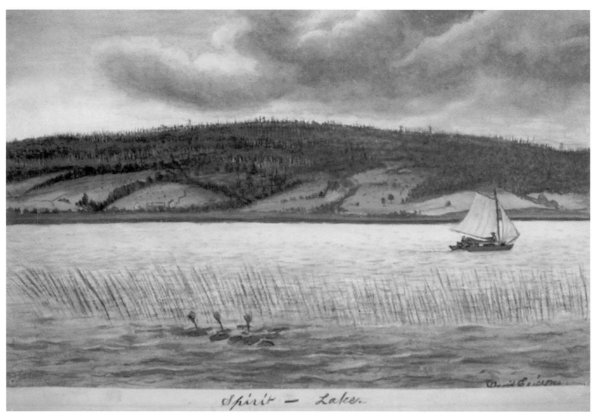

Spirit — Lake.

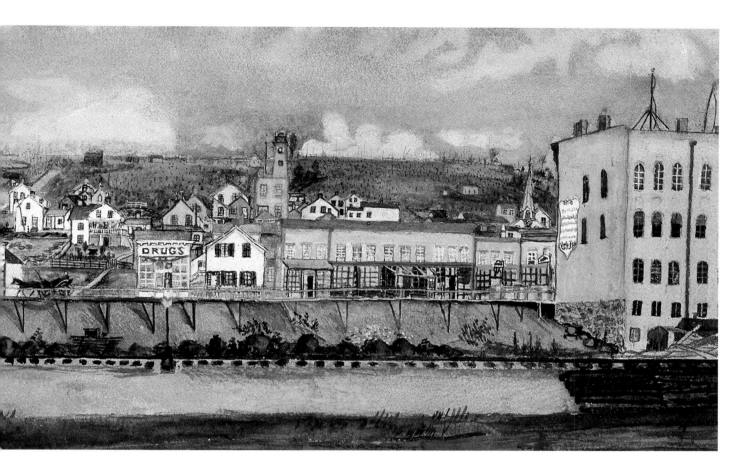

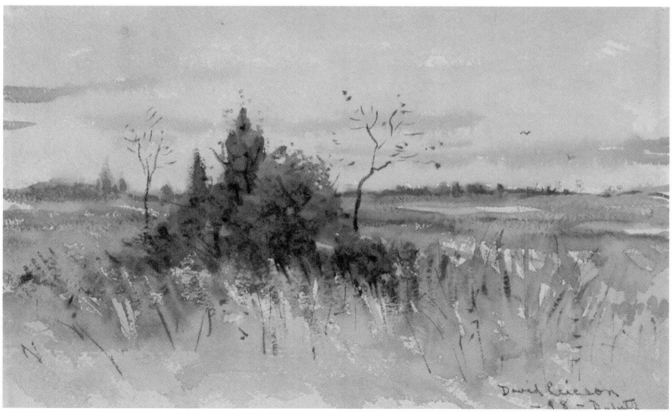

David Ericson
— 98 — Duluth

SHEPHERD AND SHEEP, ca. 1910 – 1920
oil on canvas, 16" x 20"
Collection of Joanne Halsey

SALTING THE SHEEP, 1885
oil on canvas, 30 ¼" x 40"
Tweed Museum of Art
Gift of the Estate of Mrs. A. M. Miller

SHEEPHERDER, 1903
oil on canvas, 22" x 30"
Tweed Museum of Art
Gift of the Estate of George H. Crosby

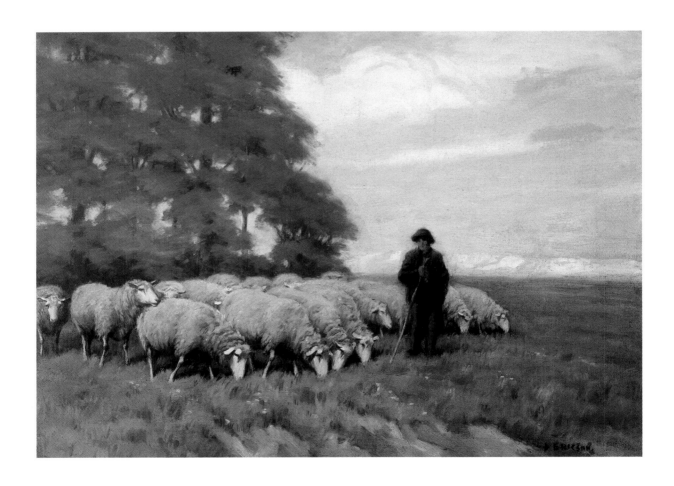

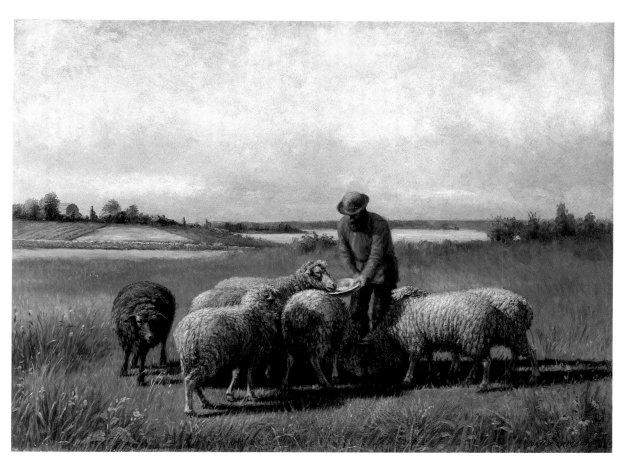

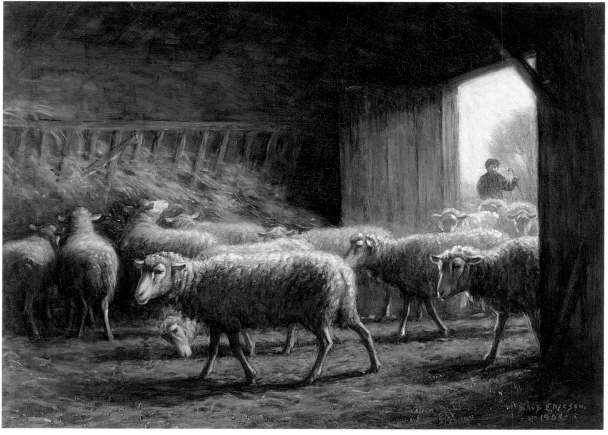

PORTRAIT OF THE ARTIST'S BROTHER, CHARLIE, 1902
oil on canvas, 16" x 13"
Tweed Museum of Art
Gift of Gerald B. Thoreson

PORTRAIT OF THE ARTIST'S SISTER, VICTORIA, ca. 1902 – 1910
oil on canvas, 15" x 13"
Tweed Museum of Art
Gift of Mrs. C.M. Brewster

PORTRAIT OF THE ARTIST'S MOTHER, ca. 1890 – 1900
oil on canvas, 10" x 8"
Tweed Museum of Art
Gift of Mrs. C. M. Brewster

NIGHT AND DAY, n.d.
oil on canvas, 32" x 40"
Collection of Tiss Underdahl

INDIANS ON HORSEBACK, 1925
Cast bronze, 11" x 14" x 8 ½"
Tweed Museum of Art
Gift of Dr. David B. Ericson

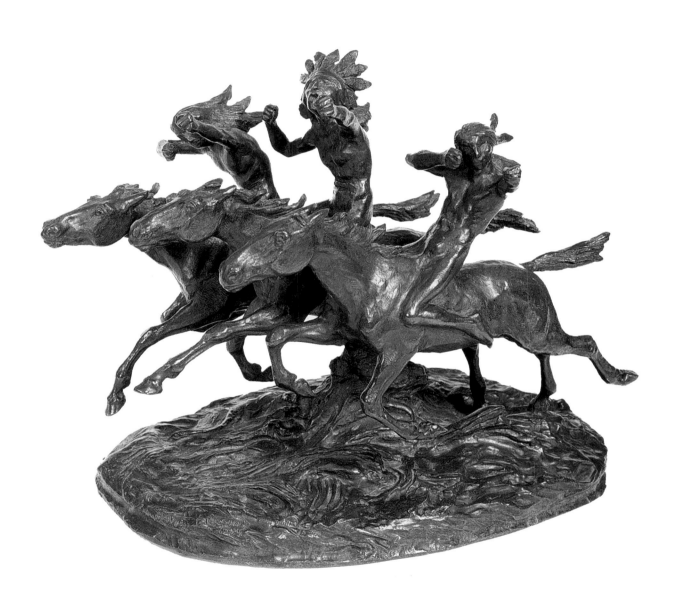

PORTALS OF THE PAST, 1926
oil on panel, 14" x 25"
carved and painted frame, 21" x 35 ⅛" x 2"
Tweed Museum of Art
Gift of the Nat G. Polinsky Rehabilitation Center
Carved inscription on frame reads:
"In memory of Keith Allen Barnes,
1904 – 1921, This Work Was His Vision."

ASCENSION, ca. 1905
oil on canvas, 110" x 80"
Gloria Dei Lutheran Church, Duluth
This painting was done by the artist in memory of his mother,
who died in 1905, and was a member of this church.

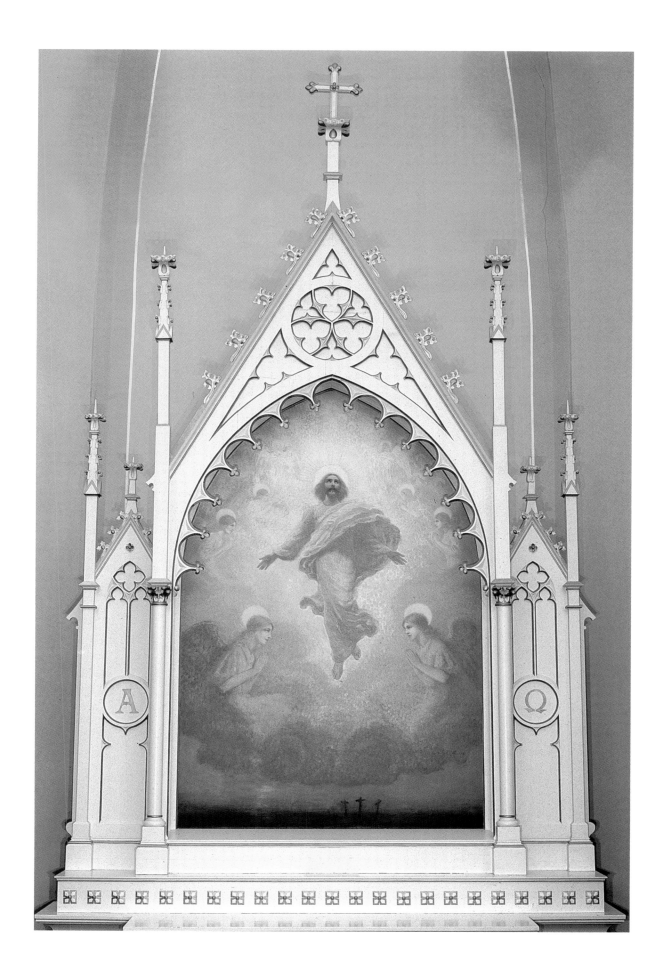

ICONOSTAS, 1944
series of 24 icons, oil on canvas over wood
St. George Serbian Orthodox Church, Duluth

detail:
ST. GEORGE THE GREAT MARTYR

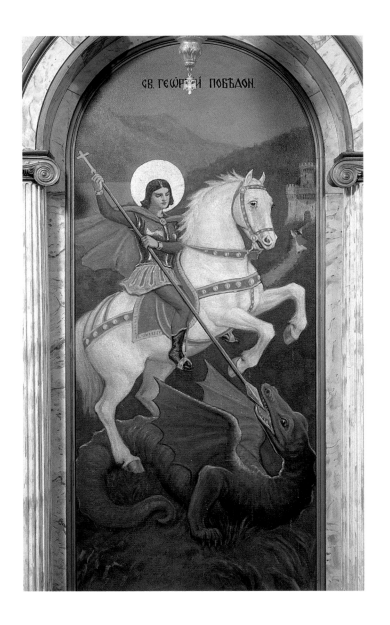

PENCIL DRAWINGS FROM
SKETCHBOOK, ca. 1900 – 1910
44 pages, 6 ⅝" x 10"
unidentified sitters and studio interior

PORTRAIT OF STEPHEN CRANE, 1892 (6-20-92)
oil on board, 11" x 7"
Tweed Museum of Art
Gift of Dr. David B. Ericson

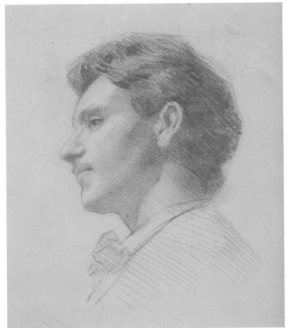

SCRIBNER'S, 1893 – 1824
"Scribner's – for March –
Now Ready – Everybody is
talking of "The House of Mirth,"
by Edith Wharton in Scribner's –
Are you reading it?"

LIFE MAGAZINE
Cover art, May 5, 1905
"Women with Flowers"
"The Simple Life"

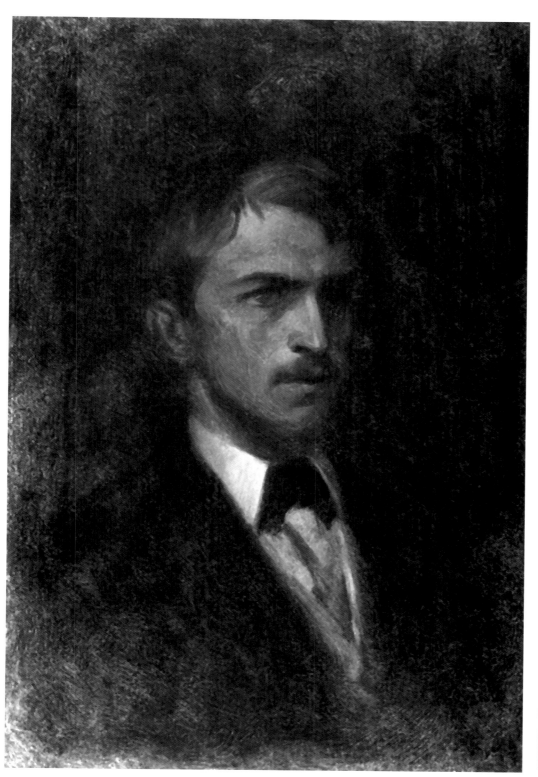

Everybody is talking of
"THE HOUSE OF MIRTH," by
Edith Wharton in Scribner's
Are you reading it?

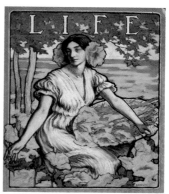

BLUE LANDSCAPE WITH
NYMPHS DANCING,
ca. 1900 – 1910
oil on canvas,
30" x 38 ⅛"
Tweed Museum of Art
Gift of Mr. and Mrs. C. M. Heimbach

GRAVEYARD SERMON,
ca. 1900 – 1910
oil on canvas
board. 8 ⅛" x 11"
Tweed Museum of Art
Gift of Mr. Howard W. Lyon

NATIVITY,
ca. 1910 – 1919
oil on canvas, 86" x 60"
Tweed Museum of Art
Alice Tweed Tuohy
Foundation Purchase Fund

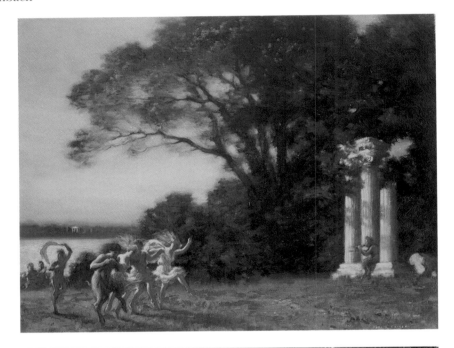

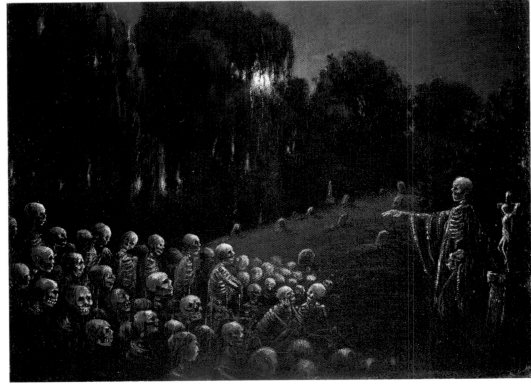

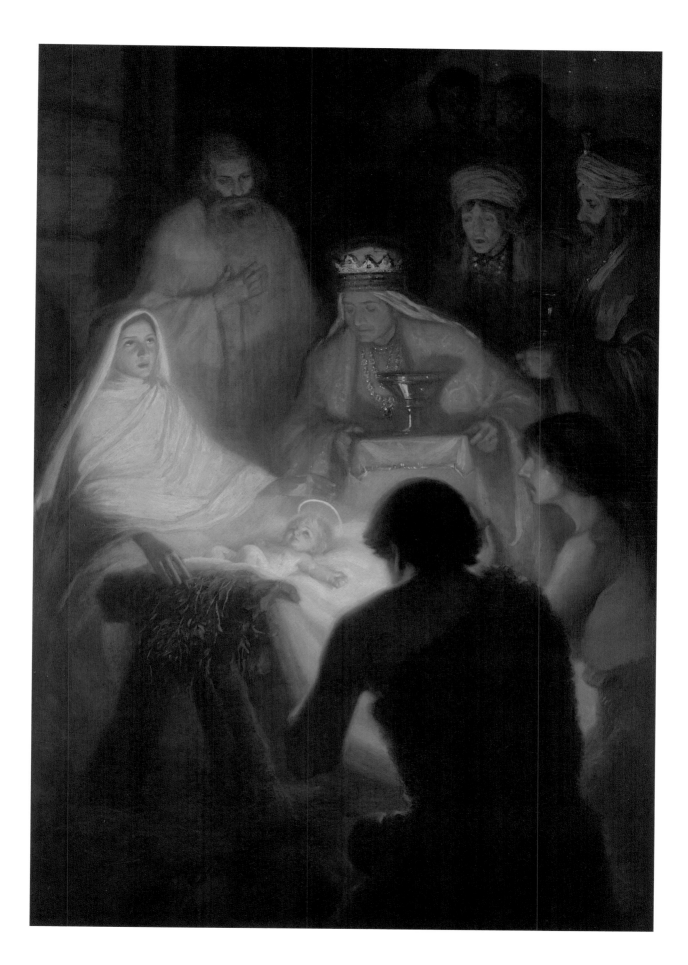

**THE SPINNER
(PONT AVEN, FRANCE), ca. 1900 – 1903**
oil on canvas, 29" x 30"
Collection of Duluth Public Library,
City of Duluth

THE SHEIK, ca. 1900 – 1910
oil on canvas, 22" x 18"
Anonymous Private Collection

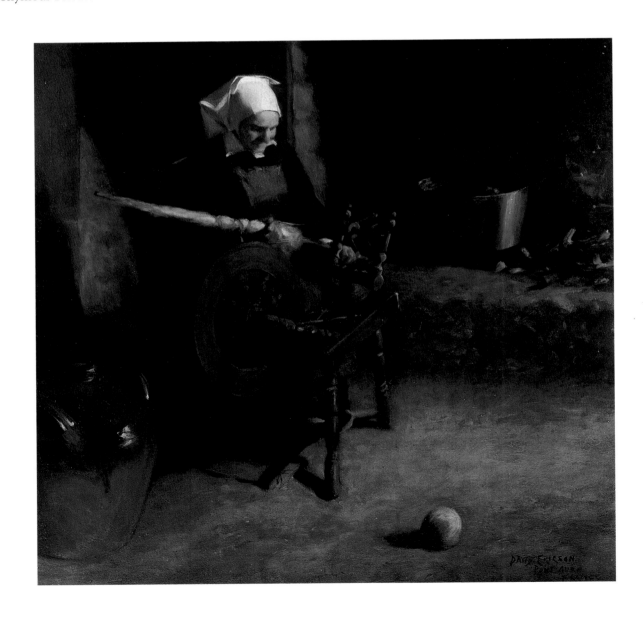

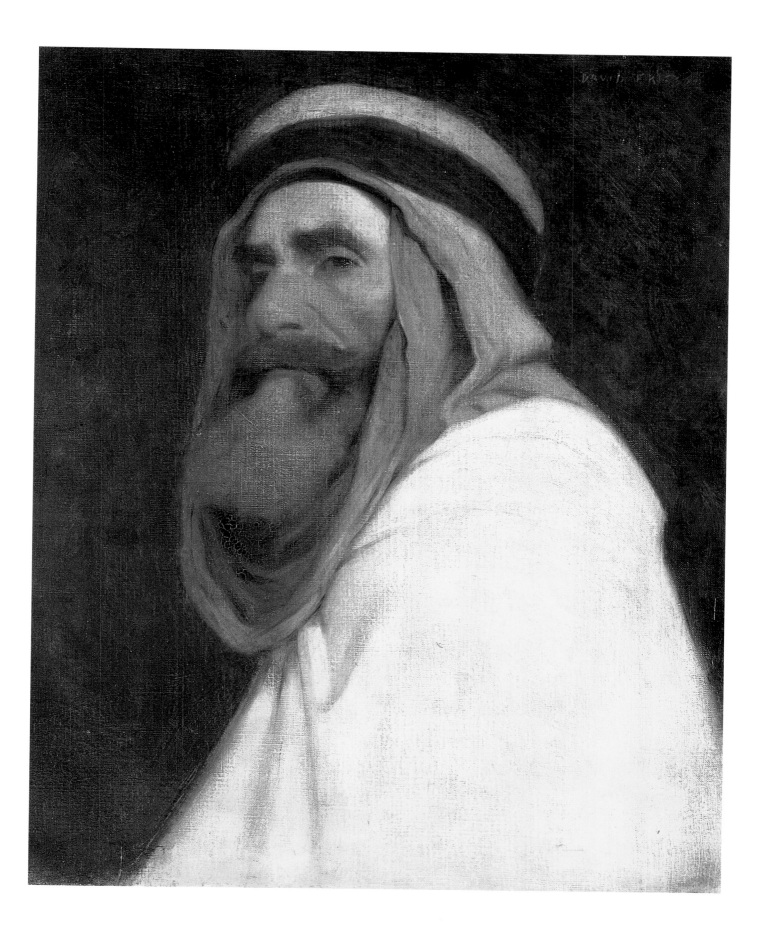

MORNING OF LIFE, 1907
oil on canvas, 27" x 22 ¼"
Tweed Museum of Art
Gift of Mrs. E. L. Tuohy

BOY WITH TOY SAILBOAT,
ca. 1910 – 1912
oil on canvas, 36 ¼" x 27 ⅝"
Tweed Museum of Art
Gift of Dr. David B. Ericson

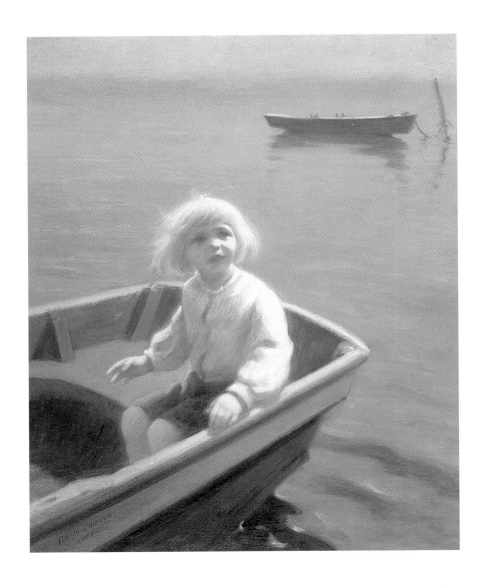

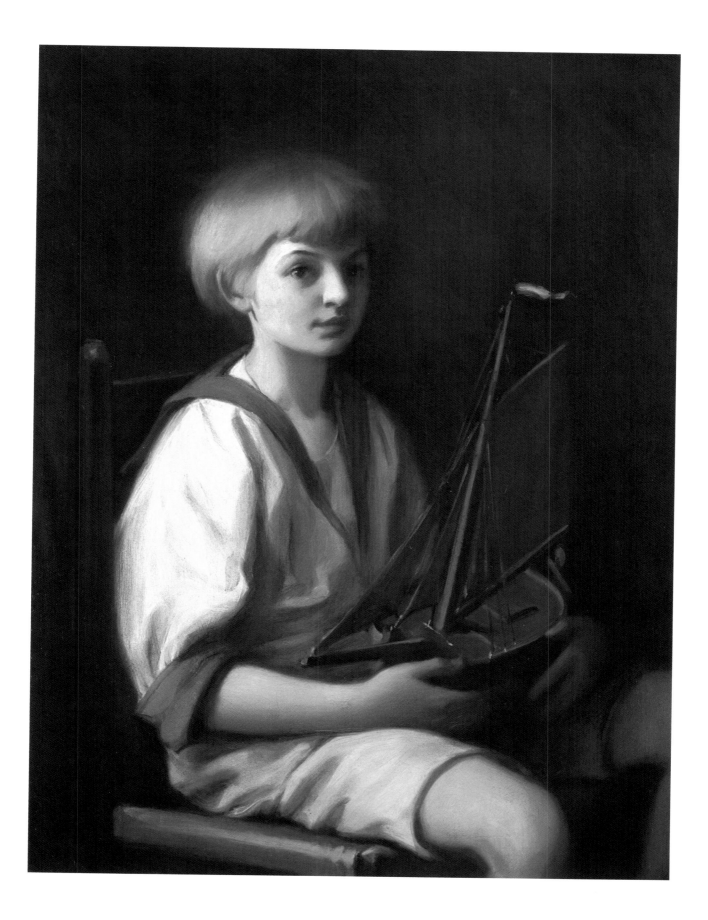

WOMAN AT DRESSING TABLE,
ca. 1920 – 1930
oil on canvas, 26" x 26"
Tweed Museum of Art
Gift of Catherine Boynton

BY LAMPLIGHT, 1920
oil on canvas, 40" x 35"
Tweed Museum of Art
Gift of Dr. David B. Ericson

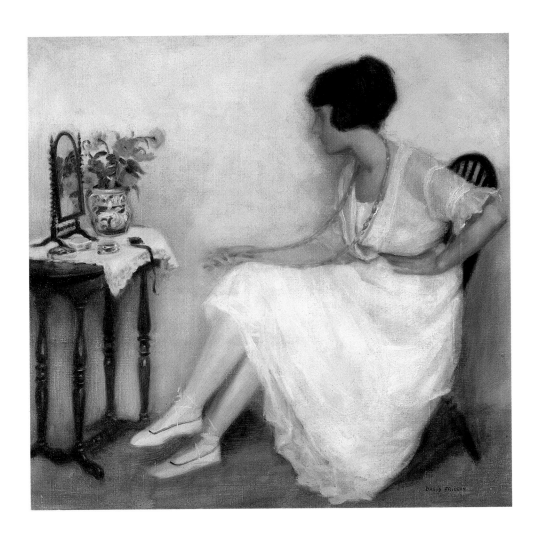

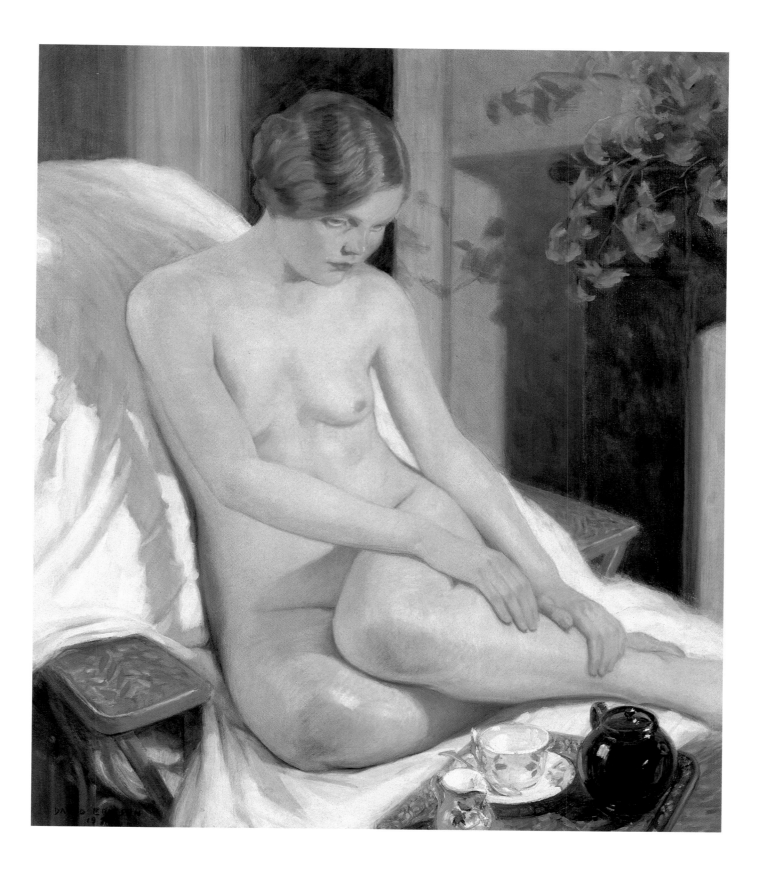

THE GREEN CAPE, ca. 1920s
oil on canvas, 40" x 40"
Tweed Museum of Art
Gift of Dr. David B. Ericson

WOMAN IN BLACK COAT, ca. 1925 – 1935
oil on canvas, 45" x 35"
Tweed Museum of Art
Gift of Dr. David B. Ericson

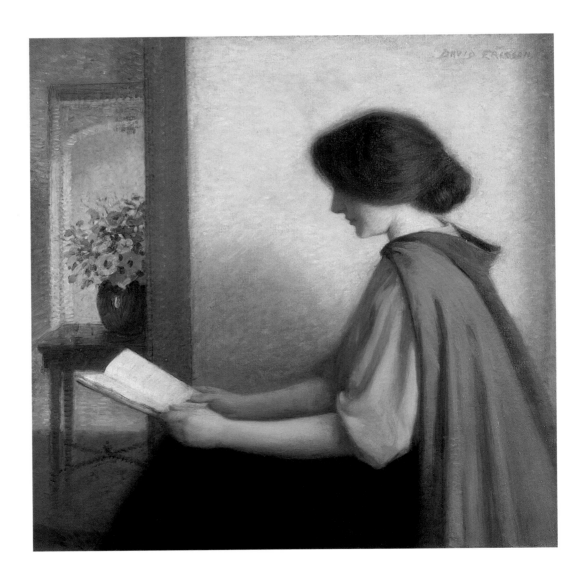

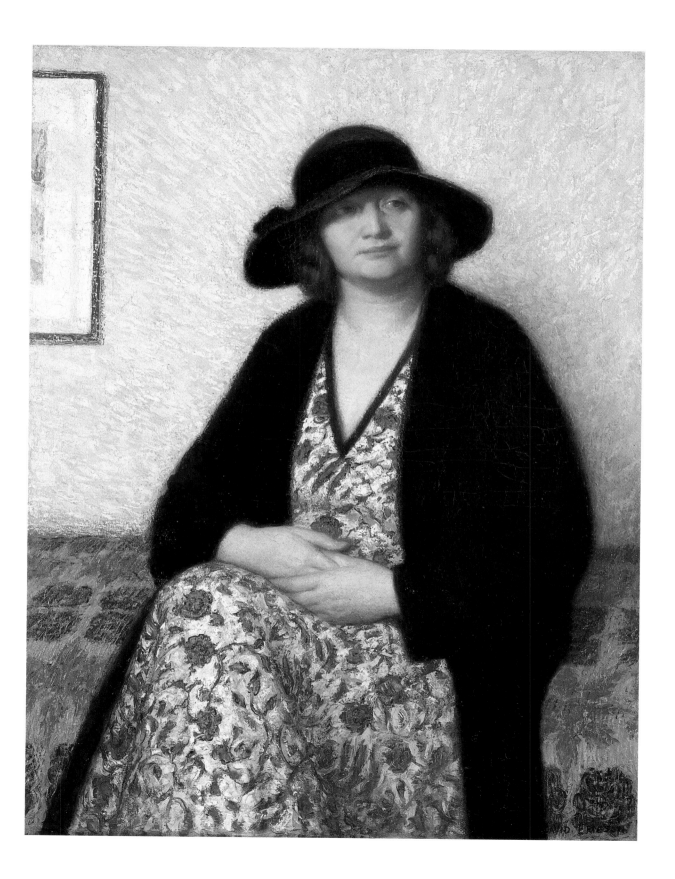

**UNTITILED (HARBOR SCENE
NEAR ETAPLES, FRANCE) ca. 1912 – 1914**
oil on board, 5" x 8"
Tweed Museum of Art
Gift of the Estate of Bernice T. Brickson

**UNTITILED (WASHERWOMEN
NEAR ETAPLES, FRANCE) ca. 1912 – 1914**
oil on board, 5 ½" x 8"
Tweed Museum of Art
Gift of the Estate of Bernice T. Brickson

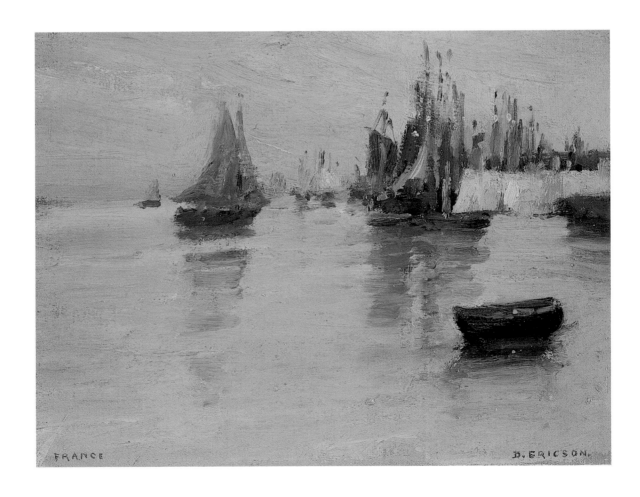

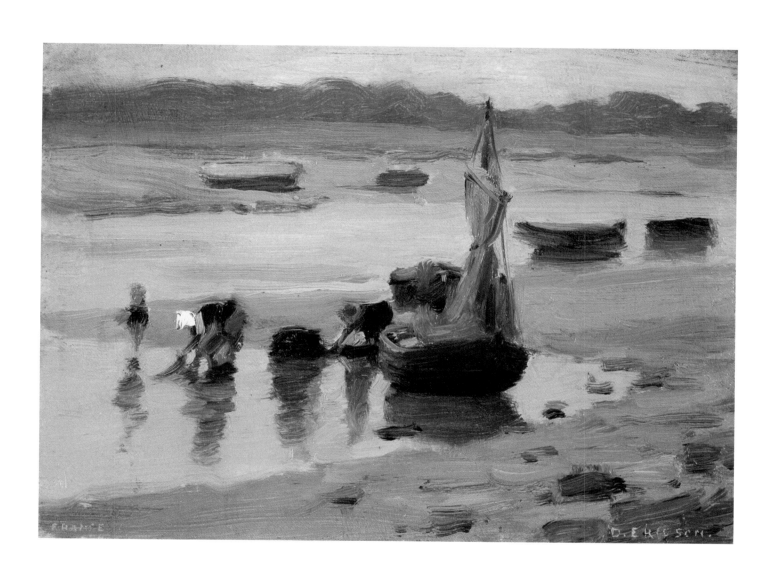

BRITTANY FAIR (MARKETPLACE), ca. 1920s
oil on canvas, 21 ¾" x 26"
Tweed Museum of Art
Gift of Theresa M. Wood Estate

**UNTITILED (STREET SCENE
NEAR ETAPLES, FRANCE) ca. 1912 – 1914**
oil on board, 5" x 8"
Tweed Museum of Art
Gift of the Estate of Bernice T. Brickson

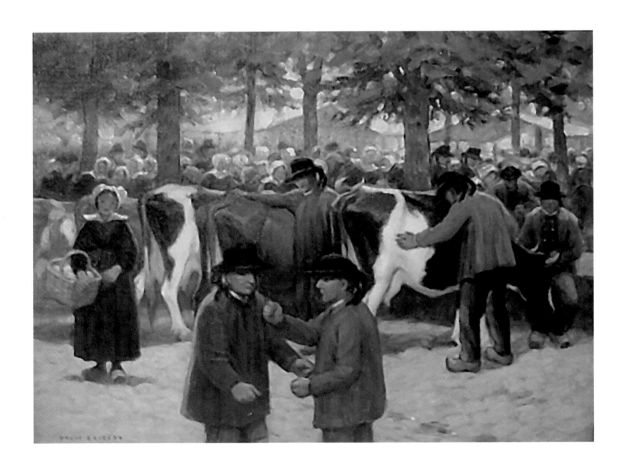

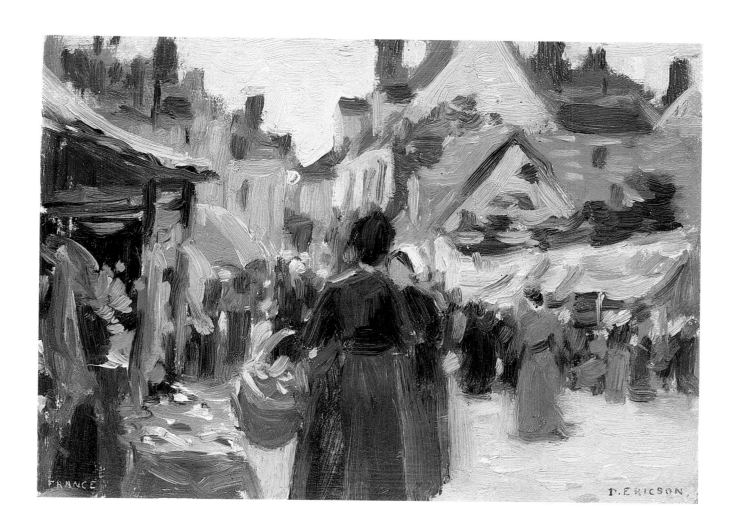

MOONLIGHT MARINE (MOONLIGHT), 1926
oil on canvas, 28" x 36"
Tweed Museum of Art
Gift of the Estate of Theresa M. Wood

SAILING SHIP, ca. 1920s
oil on canvas, 32" x 36"
Tweed Museum of Art
Gift of Mrs. A. Y. Peterson

UNTITLED (SEASCAPE WITH SHIPS, PRIMEL TIVISTERE) ca. 1920s
oil on canvas, 22" x 32"
Collection of Margaret Jost

DANIEL DE GRESOLON, SIEUR DULHUT OF THE ROYAL
GUARD OF LOUIS XIV, AT SAINT-GERMAINE-EN-LAYS,
ON THE SEINE, ca. 1920 – 1930
oil on canvas, 46 ¼" x 57 ¾"
Collection of St. Louis County Historical Society, Duluth

BOUJITAL SUR SEINE, 1938
oil on canvas, 32" x 26"
Collection of R. Craft and Eleanore Dryer

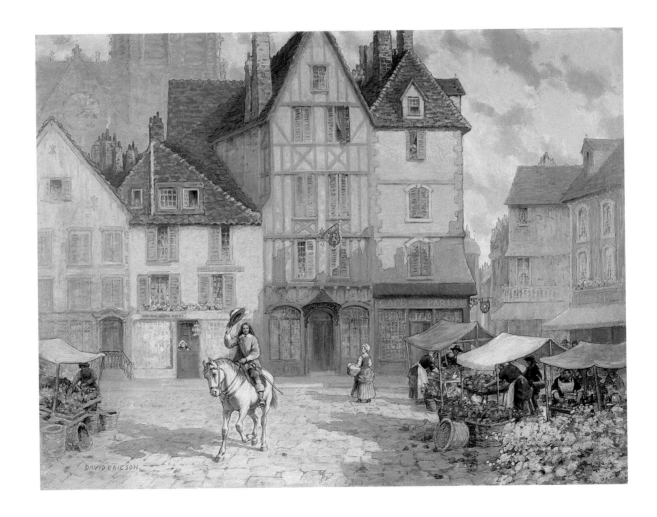

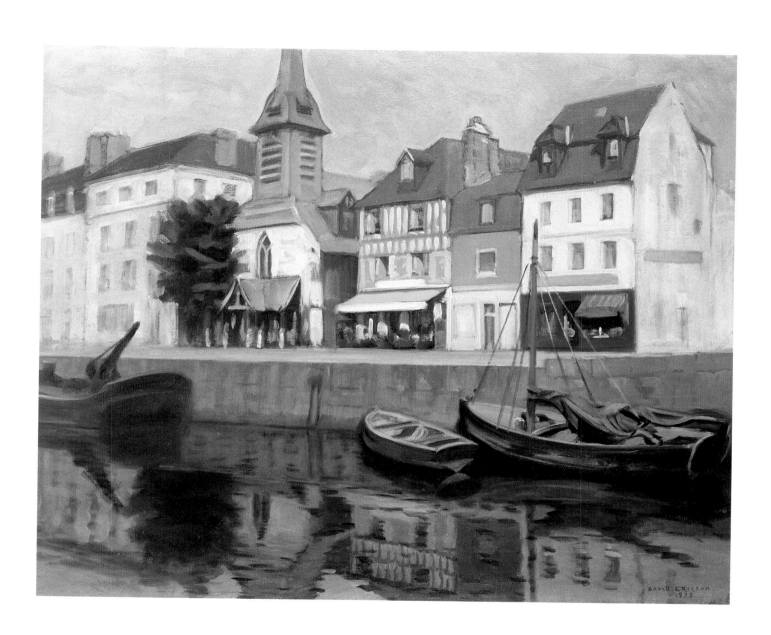

FISHERMAN'S COTTAGES
(EARLY MOON-RISE), ca. 1915 – 1924
oil on canvas, 24" x 30"
Collection of Joanne Halsey

UNTITLED (WINTER LANDSCAPE), ca. 1915 – 1925
oil on canvas, 30" x 24"
Collection of Neal and Kathy Hesson

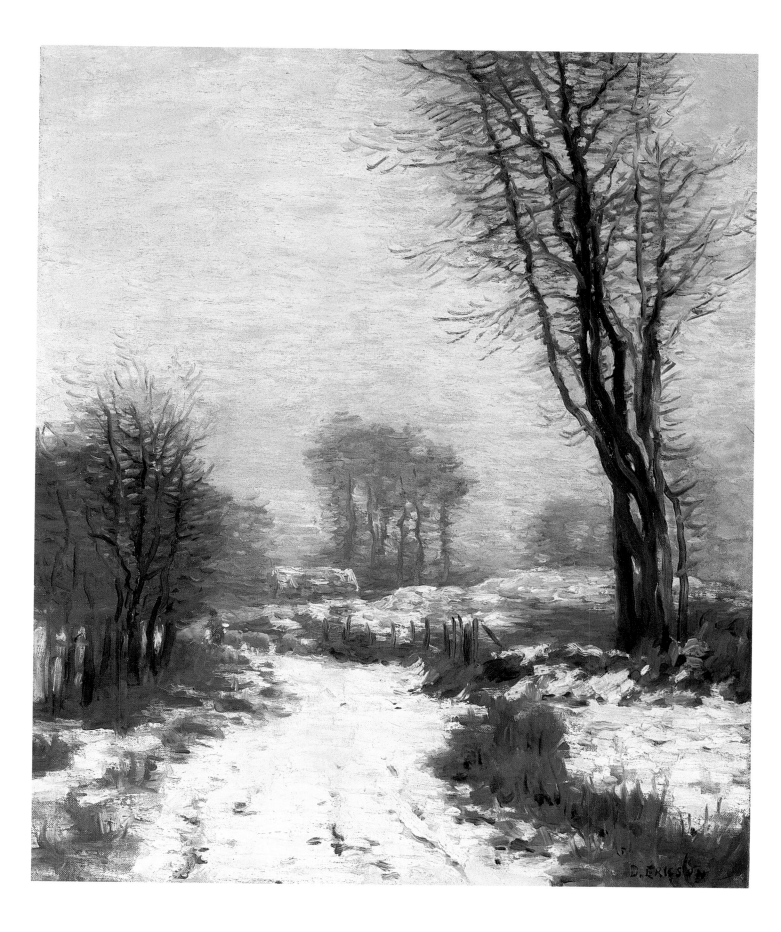

PONTE DELLA CALCINA, ca. 1930s
oil on canvas, 32" x 32"
Tweed Museum of Art
Gift of Dr. David B. Ericson

OLD BRIDGE, CHIOGGIA, ca. 1930s
oil on canvas, 32" x 32"
Collection of Dan and Chris King

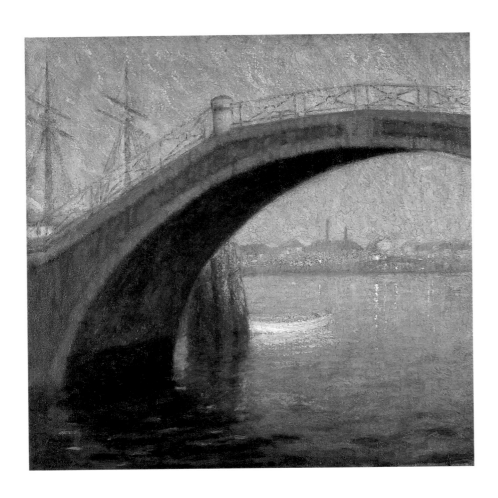

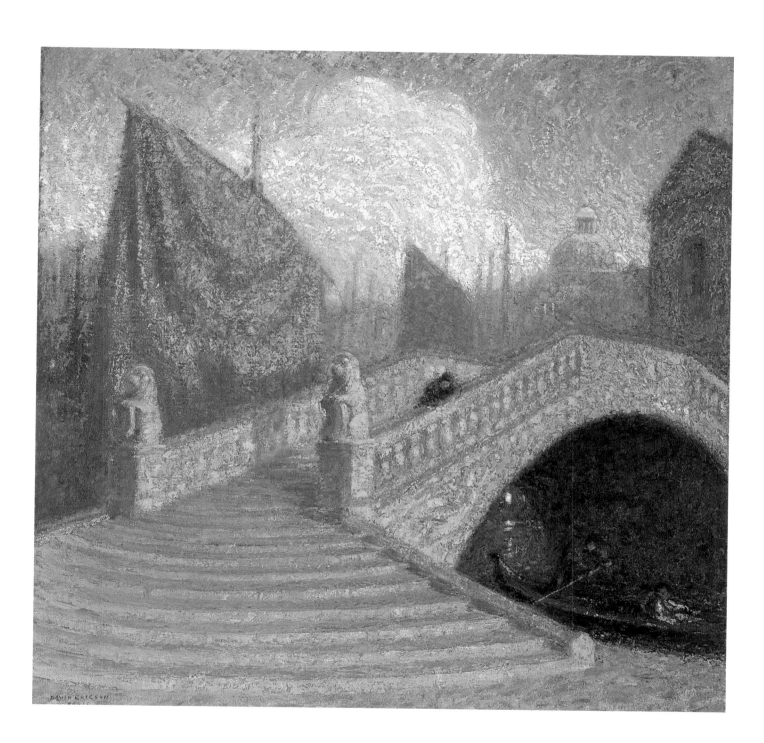

COAST OF BRITTANY, 1910
oil on canvas, 28" x 36"
Tweed Museum of Art
Gift Mrs. A. M. Chisholm

BRUGES, BELGIUM, ca. 1912 – 1914
oil on canvas, 22" x 18"
Collection of Glensheen Historic Estate,
University of Minnesota Duluth

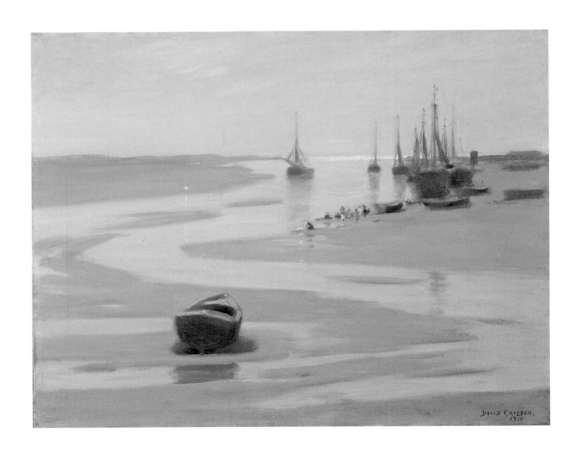

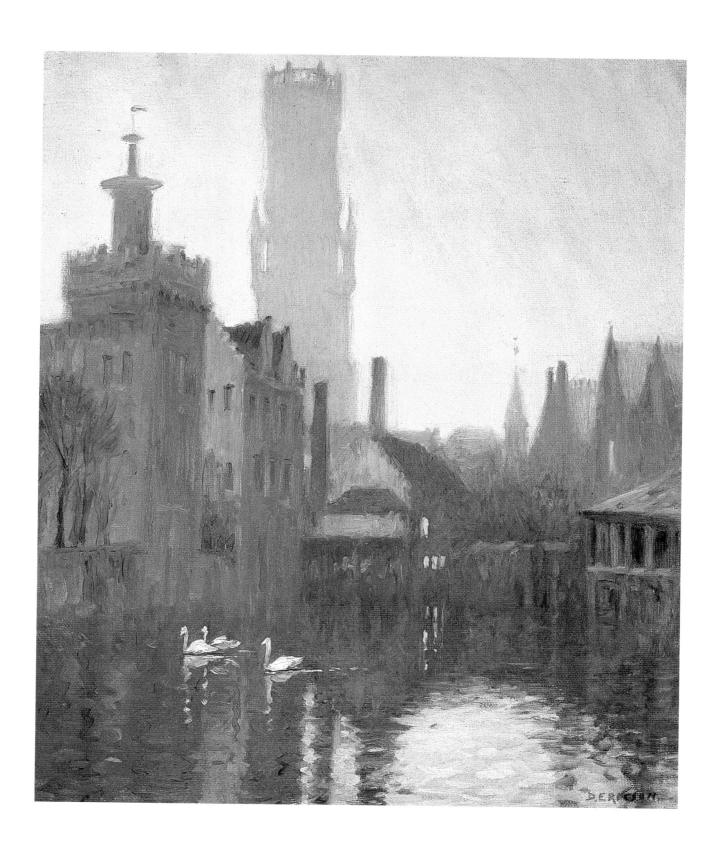

INTERIOR, GORCHES, ca. 1920s
oil on canvas, 25" x 21 ⅛"
Collection of Beverly Goldfine

FRUIT (STILL LIFE), ca. 1915 – 1925
oil on canvas, 23 ⅝" x 23 ¼"
Tweed Museum of Art
Gift of Dr. David B. Ericson

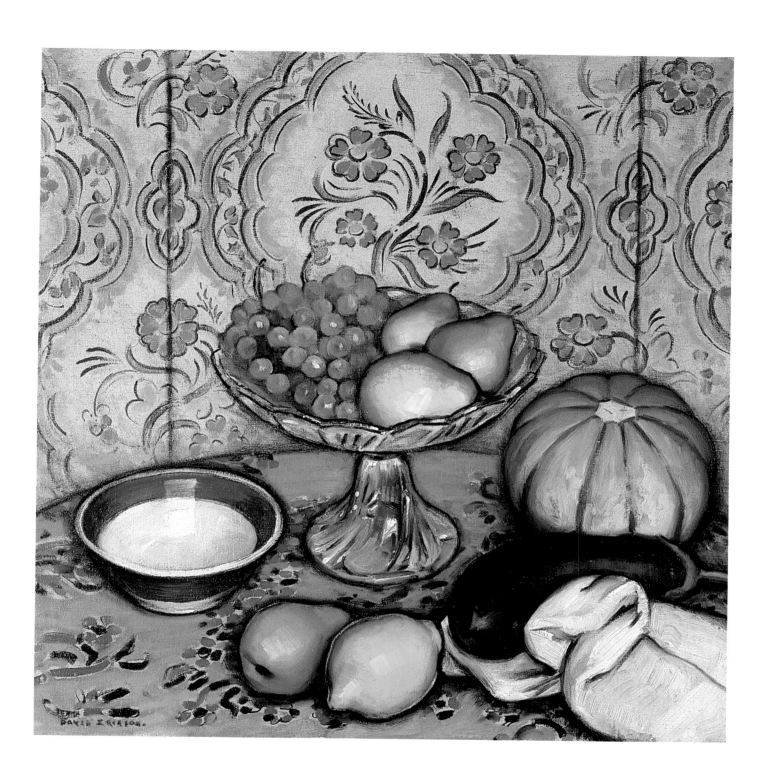

LANDSCAPE, FRANCE, 1925
oil on board, 10 ⅝" x 13 ⅞"
Tweed Museum of Art
Gift of Mrs. C. M. Brewster

FIELDS, 1927
oil on canvas, 40" x 38"
Tweed Museum of Art
Gift of Dr. David B. Ericson

UNTITLED (PLOWING), ca. 1925
oil on canvas, 30" x 40"
Tweed Museum of Art
Gift of Mrs. Frances E. Getzen

ALPS MARITIME, 1925
oil on canvas, 25 ⅝" x 32"
Tweed Museum of Art
Gift of Dr. David B. Ericson

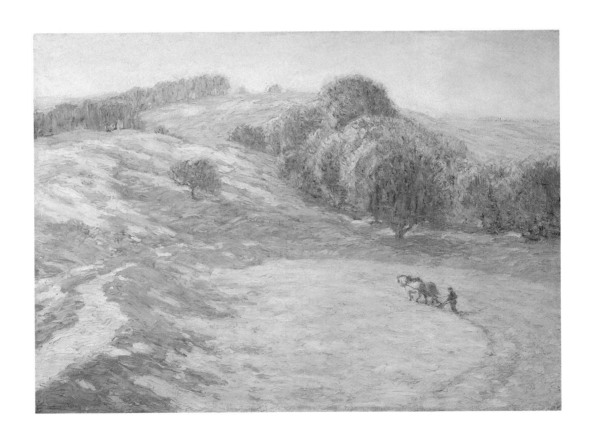

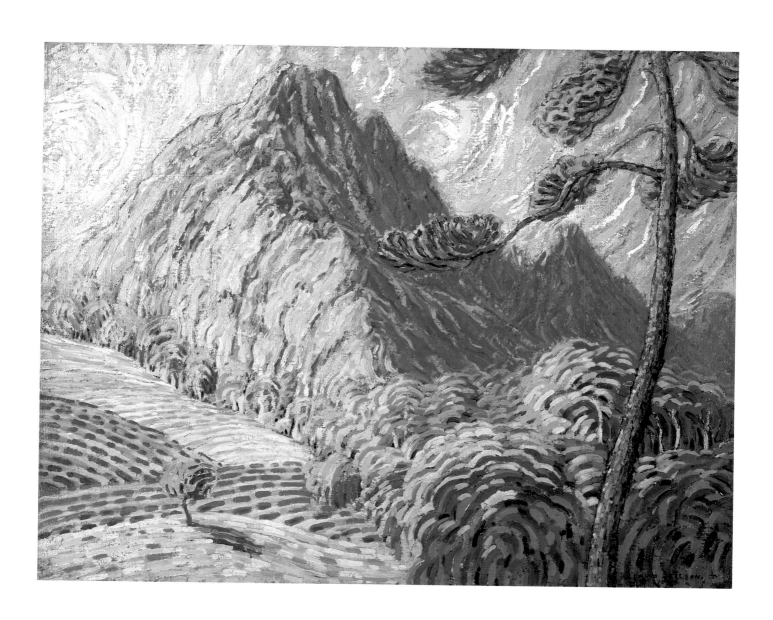

THE GREEN HOUSE AT ELVERHOI, ca. 1914
oil on canvas, 40 ³/₈" x 40 ³/₈"
Tweed Museum of Art
Gift of Dr. David B. Ericson

MOUNTAIN TOWN, ca. 1925
oil on canvas, 25" x 19"
Tweed Museum of Art
Gift of Dr. David B. Ericson

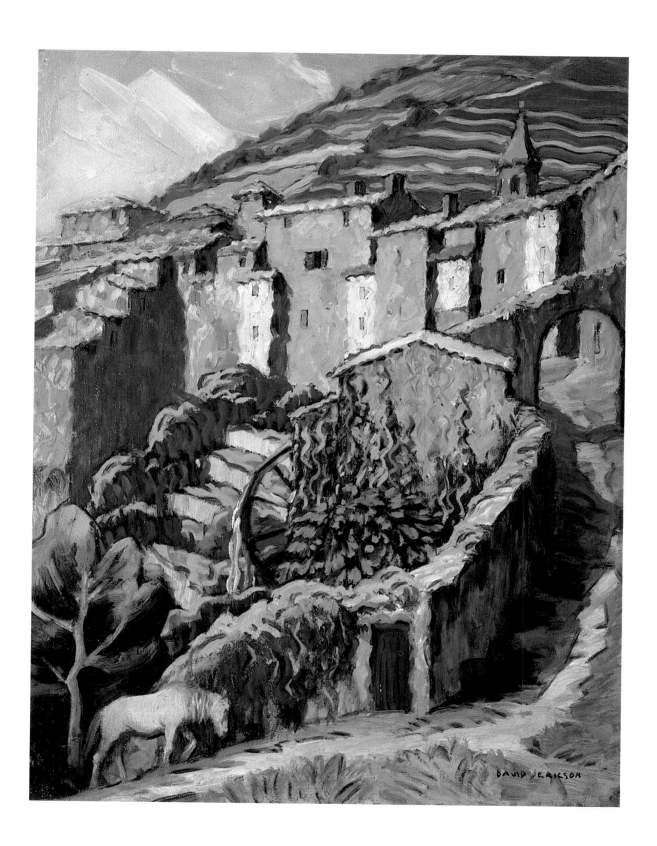

CHIESA DELLA SALUTE, ca. 1930s
oil on canvas, 31 ¾" x 31 ¾"
Tweed Museum of Art
Gift of Dr. David B. Ericson

OLD PALACE IN THE MOONLIGHT, ca. 1930s
oil on canvas, 31 ¾" x 31 ¾"
Tweed Museum of Art
Gift of Dr. David B. Ericson

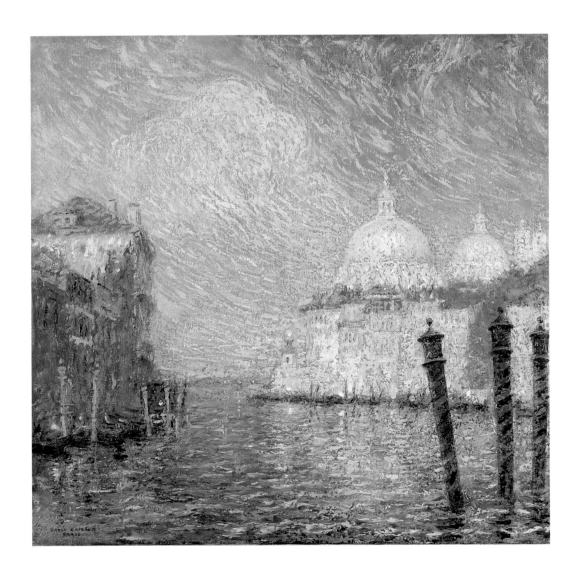

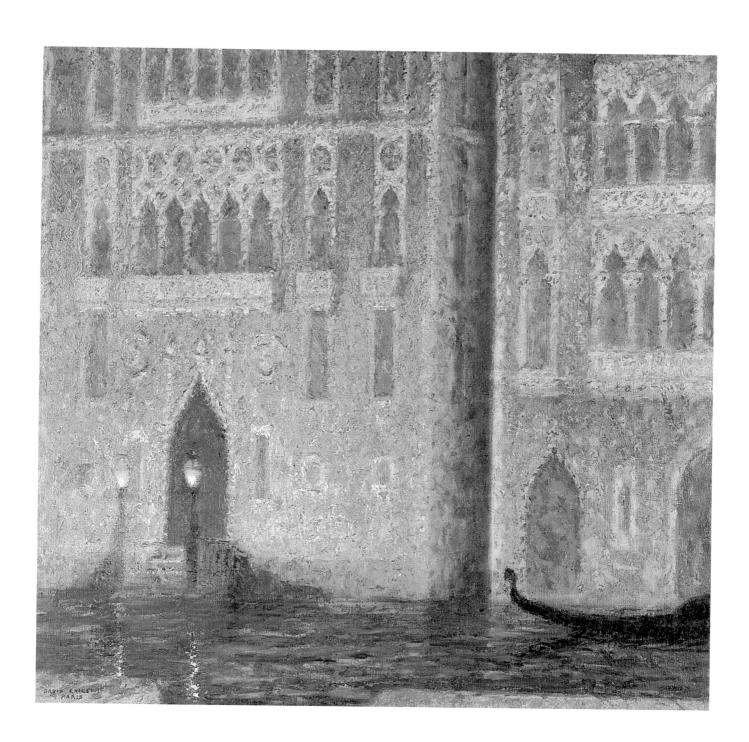

OLD TIDAL MILL, PLUMANAC'H, BRITTANY FRANCE, ca. 1926
oil on canvas, 13" x 16 ¼"
Tweed Museum of Art
Gift of Mrs. C.M. Brewster

FISHING BOATS AT REST, ca. 1928
oil on canvas, 31" x 25"
Collection of Dr. William Rudie

EVENING STAR, ca. 1930s
oil on canvas, 40" x 40"
Tweed Museum of Art
Gift of Dr. David B. Ericson

TUCSON, ARIZONA GARDEN, 1943
oil on canvas, 24" x 29"
Collection of Glensheen Historic Estate,
University of Minnesota Duluth

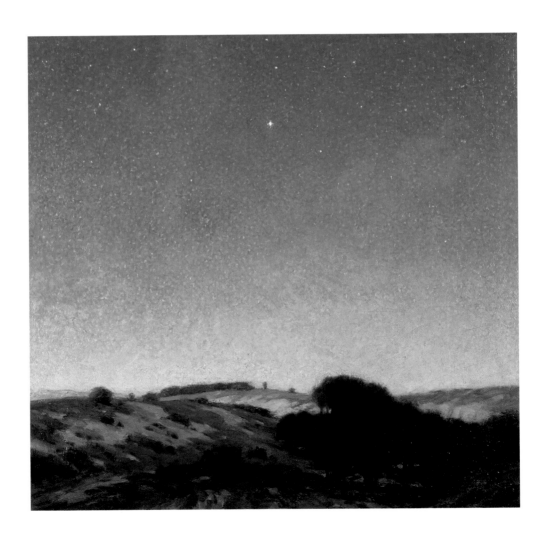

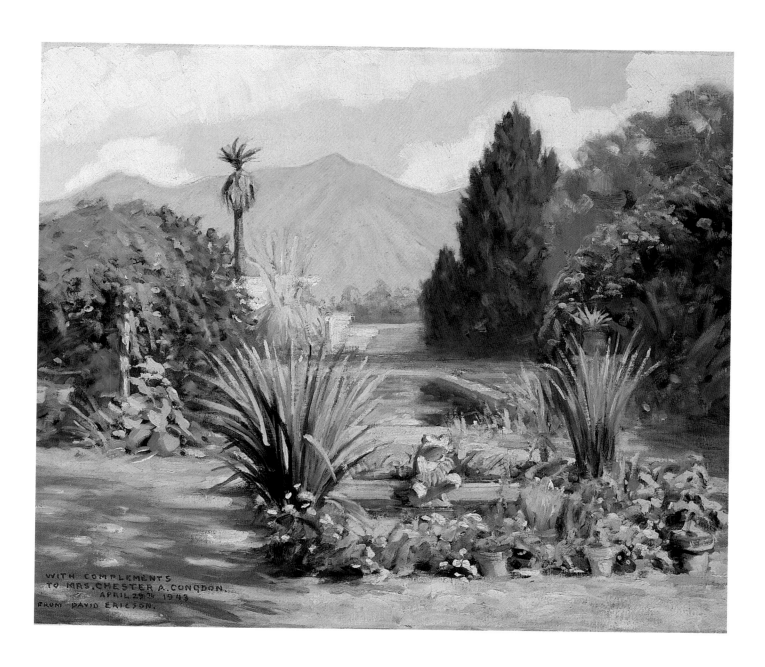

WITH COMPLEMENTS
TO MRS. CHESTER A. CONGDON.
APRIL 29th 1943
FROM DAVID ERICSON.

DAVID ERICSON AND DULUTH:
An Interview with Frances McGiffert

Frances McGiffert (nee Harrison) was born April 16, 1909 and was one of many aspiring artists from Duluth who studied with the painter David Ericson in the mid-1930s. This interview speaks of Ericson's influence and explains how Frances McGiffert came to model for the central figure in Ericson's 1936 painting, *The Circus*. Tweed Museum curator Peter Spooner interviewed Frances McGiffert at her Duluth home, May 25, 2004.

PS How would you describe your life growing up in Duluth?

FM I was born down on London Road, and I was immediately flung into St. Paul's Church for baptism!

PS And I understand you are still a very active member.

FM I am, they consider me a relic! I have always lived here. I went to what they called the lab school at the State Teacher's College (now UMD). That was a small semi-private elementary school. The lab school was at 2205 E. 5th Street. Later, all my girlfriends seemed to fade away, going off to boarding school for high school while I was left [in Duluth]. After my mother was widowed I lived with my grandmother in a house not far from where I live now. I went to public school with another friend whose cousin, John Peyton, was a well-known artist. We quickly made friends since we were abandoned by our little group. So, I graduated from high school and went to Sweet Briar, Virginia for college. Several cousins and my grandmother Harrison lived there. We have a strong Rebel element on that side of the family; half my family was from the South, and half from the North. What a tangle things really were! I even have a [land] decree from King James to the ancestors of my husband's family [from Schenectady, New York, dated May 20, 1715]. You can see that the Indians couldn't sign, so they just put their mark on it. The Indians there were Mohawk.

When I returned home to Duluth I worked in a bookshop with Barbara Hornby. Then, I married my beloved in 1939, and we had a very wonderful life.

PS How did you come to know David Ericson?

FM It seems like he was always a figure in my life and in the life of my family. He was also a protégé of family friends, Mr. & Mrs. F.W. Paine. They were wonderful people who made it possible for Ericson to do a great many things [in the pursuit of his development as an artist] that his own family really couldn't have done for him.

Around 1935, I studied painting with [Ericson]. His studio at that time was in the Hotel Duluth. It was a lovely place to be because the walls were covered with so many paintings. I can see one just now, in my mind's eye, with its solid fields of color, like a Cézanne,

really, and a painting he had at that time, of St. Marks in moonlight. I also remember a painting of Honfleur that was typical of his work at the time. These paintings had a rather gentle impressionist exterior that did not mask the force of his drawing, or get in the way of understanding what he was painting. His paintings could be deceptive, as they had mystery, yet were also strong depictions.

PS With a home in Provincetown, and having lived for extended periods in Europe, returning to Duluth must have had some significance. Throughout Ericson's life, he would return to operate his school of painting. Wasn't it around 1935 that you studied painting with him in his Duluth studio?

FM Yes. As were several others; there was Arthur Josephs' mother, and Miriam Blair the pianist, and her quite elderly mother, Mrs. Smith. And of course Margaret Hunner was in the class. Ericson was really quite good at helping us. I almost felt that I had a David Ericson influence in one of my paintings because he [really did] put a few brush strokes on it that gave it more than I would have accomplished myself.

PS It's interesting to think of all the teaching artists in Duluth. Ericson, of course, but also Knute Heldner, Paul Van Ryzin, and people like Gerry Pierce who was known for etching, but took up watercolor later in his career. Pierce offered workshops at a school he established in Tucson. I know Julia and Caroline Marshall studied with him there, and then he came to Duluth to give workshops. I understand that the Marshall sisters were a force behind the arts here.

FM Yes, and Julia Marshall's paintings were just lovely. Lisa Hutchinson studied with Pierce as did Margaret Hunner and Mabel Stevenson.

PS He was a fine watercolor painter, and younger than Ericson and Heldner. Pierce was born in 1900, but they all shared the same students: Mrs. Josephs, Elizabeth

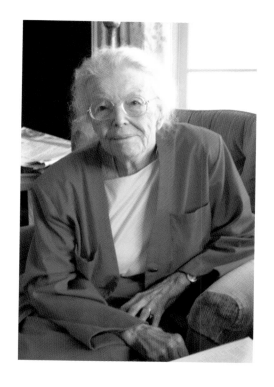

Congdon, Margaret Hunner. I think though, as an artist and teacher, Ericson's reputation beyond the region was probably greater than other artists that were here. Is that how you saw it?

FM Ericson had a charisma you couldn't resist, even if you didn't even know anything about his paintings you were drawn to him.

PS Did you continue painting after studying with David Ericson?

FM More or less, but I came to be more interested in sculpture, in part because I have always had very poor vision. My paintings were mainly posed portraits, and landscapes. I spent the summer of 1936 in France, at the Ecole de Beaux Arts in Fontainebleau, an American school established there after WWI. This was a very

Circus, ca. 1935
oil on canvas, 34 ⅛" x 30"
Tweed Museum of Art
Gift of Dr. David B. Ericson

interesting environment, because they had the art school, and a music school. Two art professors there, Carlieux and Labatu, were from Princeton. Denis Gelin, my professor in sculpture, had done some of the interior design and sculptures for the ocean liner *Normandie*. Through Carlieux we got to learn about architecture, while living in the little town of Fontainebleau.

PS Were you sculpting in clay?

FM Yes, clay models, that were never cast. But we were working from life and it was a very satisfying experience. I found that my training with David helped a great deal. Margaret Hunner was also there, and because both of us had studied with Ericson we thought of him a great deal during that summer. When we got back, Margaret and I organized a Beaux Arts Ball fundraiser for the Duluth Playhouse, which was then called the "Little Theatre." We took over the Hotel Duluth ballroom, a beautiful place. It was a circus theme, and that is how I came to be wearing the circus costume Ericson depicted in the painting. David Ericson was at the ball, as one of the judges, and he asked if I would pose for him. Of course I would have stood on my head to please him, he was such a gentle, wonderful man. This was in 1936.

After I was married in 1939 he offered the painting to me for very little as he needed the money, but I did too, so I couldn't buy it. Then, when David died in 1946, his son gave many of his paintings, including that one, to the Tweed Museum when Bill Boyce was its Director.

PS There are other paintings that easily compare to *The Circus*. For instance, the murals for Hibbing High School, a large altar painting for Gloria Dei Lutheran Church, and a whole series of paintings for the Serbian Orthodox Church in West Duluth are done in a more illustrative style, and there is another painting done in a very similar style, a style I would describe as a little more narrative or illustrative, not as loosely painted as some of Ericson's later works, and not as highly academic as his early work.

FM What is that one?

PS It is a painting of Sieur du Luth on a horse, in a courtyard in France. That painting actually surfaced three or four years ago in the collection of the former Glass Block Department Store Tea Room.

FM It seems to me that there were two paintings in that tea room, that one by Ericson and one by (Knute) Heldner.

PS It is now in the collection of the St. Louis County Historical Society. The former

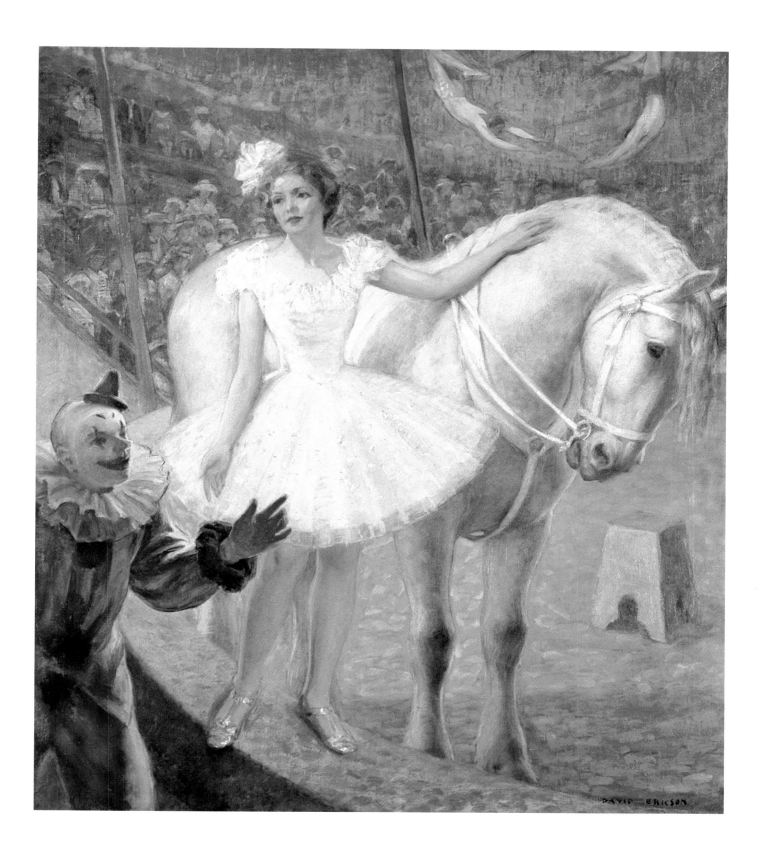

Glass Block Stores donated it to their collection. It's quite a wonderful, large narrative painting, with an obvious connection to Duluth's history. And as I mentioned, it has some strong similarities in style to the circus painting. It is a style like that of the period illustrators of the day. Howard Pyle and Ericson did do magazine illustrations -- we discovered a reproduction of a 1920's cover illustration he did for Life magazine. But I would like to ask, how long did the modeling sessions take for *The Circus*? Can you tell me anything about the horse, and the other figures?

FM It took several sittings, at different times. I was not riding the horse, and of course it was not in the studio. Ericson went out to the Whiteside Stables on the Jean Duluth Road and sketched or painted from a horse there. The clown, I have no idea if that was from imagination or if he got someone to pose. That was always a pleasant little mystery.

PS The painting does not actually seem to be a document of the circus, instead it seems to be more about the pensive attitude of the central figure, the figure you posed for. This is a very quiet, subtle, pastel-hued painting.

FM It is a fantasy you wouldn't expect, not a raucous, calliope-type circus.

After I modeled for the [Circus] painting, David gave me an etching of a flower market scene, inscribed "To Miss Frances Harrison, from David Ericson, 1936. Paris France."

PS I think that this etching illustrates what you were explaining before that the structure of drawing underneath his paintings is so evident in his prints and drawings. As a matter of fact, in 2003, the Tweed acquired an Ericson sketchbook, which together with his drawings already in the collection, shows, as this etching does, what a fine draftsman Ericson could be.

FM In his painting *St. Marks at Moonlight* it is quite evident. He could draw, but he'd subdue his technical prowess so it wouldn't overpower [the overall sense of] the painting.

PS And of course that's also what separates David Ericson from the French impressionists and their technique. There was little or no drawing underneath those fully impressionist paintings, but I think that even in Ericson's very textural, thickly painted works, there is a structure of drawing underneath.

FM I would still like to own a Renoir though!

PS Did you continue to know and associate with David Ericson even after you were married?

New Orleans, ca. 1935 – 1940
oil on board, 30" x 25"
Collection of Glensheen Historic Estate,
University of Minnesota Duluth

FM Yes, but when I came back from college in 1930, he was not in Duluth as much. I saw him occasionally and talked with him on the phone but life kept me busy and involved with other people and other things. I regretted that I didn't see more of him.

PS He frequently traveled back and forth between Duluth, Europe and Provincetown. We have been able to reconstruct what we believe to be a fairly accurate record of his where-abouts. We do know, of course, that he was in Duluth in 1946, since that was the year he was killed there.

FM That was simply awful, I remember so clearly when that happened. That it was on 12th Avenue. He was living at Mrs. Field's boarding house at the time, a very elegant place. He had just gotten off a street car, when he was hit by an automobile and killed. It was a real loss to the whole community, and particularly to the older residents in the community.

PS How do you think the community regarded him at that time?

FM I think they regarded him almost with bated breath. One time I had sort of a little gallery of my own over by my grandmother's house. I had his paintings and Heldner's and one or two others. It was a nice big house, and I would display them. There wasn't a gallery downtown at that time, so I lived with those paintings. Knute Heldner of course was a very prominent painter in Duluth who later moved to New Orleans. He married Collette Pope from the Point (Park Point, Duluth). We used to go to New Orleans quite often. Collette (Pope Heldner) was still living there when we went there. I'm no art critic but to me Heldner seemed to be a very strong painter. David Ericson dealt with nuances, and I don't know that Heldner did.

PS I understand that Ericson thought of himself as hitting his stride with the later European paintings made after he had been to Venice and had developed a somewhat unique version of Impressionism. He suggested as much in a

letter to a niece in Duluth.

FM Curiously, if you notice the dates of the work at that time, the Depression was clamping down on everyone. It didn't just stop at the buying and selling of artworks; it was a very gloomy time. I think all of us who lived through that time still bear some scars of the Great Depression. Yet, the Depression was as much a cleansing experience as it was agonizing. It was a subject that David turned out during the Depression, because he had to. Some were better than others. They were all decorative, but all very likeable and those paintings went all over the country.

PS Yes, there are many of the sailboat paintings, and we see them surfacing all over the country. The sailboat pictures were his "bread and butter," one might say. Ericson did make a decent living from his art, and from teaching painting to others.

FM For a little boy who grew up on Park Point with a dis-ability, he really became a most sophisticated person without the brassiness of so much sophistication. He never shed his sincerity, and he had a great deal of self worth. He was never aggressive, just genuine. I feel very honored to have known him.

DAVID ERICSON'S HIBBING MURALS:
A PAINTED PAGEANT FOR STUDENTS AND IMMIGRANTS
by Thomas O'Sullivan

In the most ambitious project of his long career, David Ericson composed a civics lesson for the people of the Iron Range. Painted in 1922 – 23, his cycle of six murals represents historical moments that resound with messages linking the ethnically diverse city to a national mythos. Confident yet understated in style, Ericson's murals further represent a widespread didactic role for public art between the vaporous allegorical works of the 1890s and the brawny populism of the New Deal. They serve as memorials of the Progressive Era's use of art to embellish and edify a growing and changing community.

The city of Hibbing was founded in 1893, a year after Frank Hibbing discovered the rich deposits of iron ore that became known worldwide as the Mesabi Range. The growth of this industry boosted Hibbing's population from 2,481 at the turn of the 20th century to more than 15,000 by 1920.[1] Many residents were immigrants from eastern and southern Europe, a circumstance that was manifest in public-school curricula as well as in Ericson's imagery. "Thirty-two nationalities are represented in the Hibbing schools," boasted a school brochure. "Every school building is a 'melting pot.' In 1924 – 25, more then [sic] a thousand adult aliens were enrolled in Americanization and Citizenship classes. Each spring, approximately one hundred aliens are graduated from naturalization classes, receiving their diplomas and citizenship papers."[2]

The mining industry provided the means, as well as the need, to educate and acculturate Hibbing's polyglot student body. A substantial state tax on mining company profits permitted the cities of the Iron Range to develop enviable public works and to indulge in parks, libraries, and especially schools. "Expenditures for schools of all grades were lavish beyond comparison," Minnesota educator and historian William Watts Folwell observed in 1930. "The city of Hibbing outdid all the towns on the Mesabi Range, putting $350,000 (worth more than ten times that amount in 2003 dollars using the Consumer Price Index) into a building for its grade schools and $3,800,000 into one for its high school and junior college. Few college buildings anywhere compare favorably with this structure and its equipment."[3]

Dedicated early in 1924, Hibbing High School and Junior College embodied the era's educational ideals in bricks and mortar. The school lived up to the hyperbole of contemporary boosters and later generations alike, from its early nickname "the castle in the wilderness" to its listing on the National Register of Historic Places in 1980. Its design by Duluth architect W. T. Bray projects an air of authority in "an odd but effective mix of the Medieval and the Classical," a style variously termed Collegiate Gothic or Jacobethan.[4] The characteristic vocabulary of brick walls with light stone trim and castle-like elements spelled learning and tradition on campuses across the country in the early 20th century. Bray's facade stretches over 400 feet (comparable in size to the 1905 Minnesota State Capitol) centered on a turreted stone entry pavilion. Its massive doors open to an equally grand lobby paneled in Kasota stone, floored in mosaic, and decorated with Ericson's

Hibbing High School, W. T. Bray, Architect, 1924
Hibbing High School, Interior, Main Lobby

paintings. Up the broad marble stairs were classrooms, laboratories, a vast library, and the town's showpiece, an opulent 1,805-seat auditorium said to be modeled after a New York theatre.[5]

The placement of Ericson's panels in the lobby ensured that students and townspeople would enter "the school with the golden doorknobs" through a painted pageant of Americana. To the left of the stairway hang "Columbus Discovering America," "Signing of the Declaration of Independence," and "Westward Ho" (titles as reported in a 1924 Hibbing newspaper article). To the right are "Lumbering in Minnesota," "A Naturalization Court" (also known as "Swearing Allegiance to the United States") and "Trading with the Indians." All were subjects and designs the artist had submitted to the Hibbing Board of Education for approval of the $9,000.00 commission, which was granted in November 1922.[6] They fulfilled the ideological function of history painting as "more than a mere depiction of miscellaneous past events . . . viewers were to be persuaded by the eloquence of the messenger to think higher thoughts, modify their conduct, or entertain feelings of patriotism."[7] For everyone crossing the threshold, Ericson's paintings addressed what the board called "the problem, not only of educating its children from the kindergarten through the junior college, but also the equally important duty of educating the alien adult in American standards and ideals."[8]

At the time of the commission, Ericson was a veteran painter, well into middle age with a respectable portfolio of exhibitions, awards, and critical recognition. He adopted a prevalent technique for murals in schools, libraries, and other public buildings, painting the 68 by 77 inch compositions on canvas and later adhering them to the school walls. This permitted the artist to paint them at his home in Provincetown, Massachusetts, where in 1919 his family had established what the *International Studio* magazine described as "a center of cultured sociability that is most evident at their Sunday evening at homes."[9] Ericson had first worked in the village at the tip of Cape Cod in 1916, by which date there were five art schools operating in Provincetown.[10] Despite his family socials, he seems not to have been active in the Provincetown art establishment: his son recalled that Ericson and art colony patriarch Charles W. Hawthorne, who had opened Provincetown's first art school in 1899, "did not get along."[11] Nonetheless Ericson's aesthetic was well in tune with the poetic, Impressionist-inflected paintings that were synonymous with the early art colony.

Like his Whistleresque marine scenes, the Hibbing paintings have a cool, pearlescent light that is unusual in mural treatments of historical themes. A New York critic quoted at length in the *Duluth Herald* observed that "contrary to the average mural, which is painted mainly for effect and in vivid colors that will 'carry,' these works have all the qualities of fine paintings enveloped in soft atmosphere."[12] The resulting unity of hue serves to reinforce the paintings' place as one element in architect Bray's decorative scheme, rather than assertive focal points of the entry space. Tapestry-like in their muted palette, oak leaf

Trading with the Indians (top)
Columbus Discovering America (bottom)
oil on canvas, 1922 – 1923, 68" x 77" each

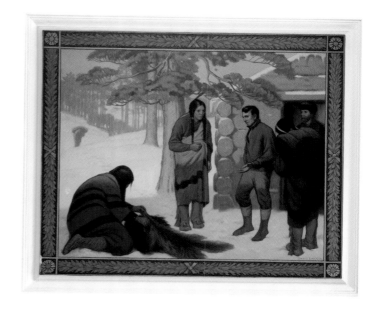

border design, and subtle but noticeable "grain" or vertical
direction of the brushstrokes, the paintings conjure up
refined spaces and a still, romantic atmosphere. A contem-
poraneous mural project just a few blocks away in Hibbing
City Hall offers a striking contrast in treatment. There the
similar historical subjects painted by H. A. Larsen and C.
Olson are rendered in deep space and strong colors, for a
strident effect that fulfills the illustrational purpose but fails
to harmonize with their architectural setting.

Ericson brought a further unity to the high school cycle by
composing the paintings in pairs, pictorially and thematically.
They equate events in northern Minnesota with larger
national stories: the European arrival in the Americas with
the fur trade that brought French, British, and American
commerce to the north woods; the logging of those same
forests with the inpouring of settlers; and the Founding
Fathers' declaration with a new citizen's profession of loyalty.
The panels "read," page-like, from left to right along each
wall, with compositions mirroring each other to reinforce
their associations visually.

The cycle begins with a pair of historical encounters spanning
centuries. "Columbus Discovering America" greets each
entering student with a triumphal rendition of the explorer,
in full panoply of flags, ships, and armor, before native men
kneeling on a Caribbean beach. On the opposite wall the
lesson continues with a fur trading scene, not as heavy-
handed but still telling in its import: the trader has built a
solid cabin as his base, before which an Indian trapper bends
to offer his furs for sale. Ericson's compositions at once
contrast and equate the scenes, balancing figures and body
language, gleaming sand and snow, palm tree and pine.

At the center of each wall, indoor scenes identify the school's
Americanization program with the foundation of American
freedom. Each panel bears its title, lest viewers misinterpret
the events: "Signing of the Declaration of Independence"
and "Swearing Allegiance to the United States" appear
on painted scrolls below the scenes. Again the composi-
tions mirror one another, from the color scheme to the

dais to the rows of seated observers in each scene. "Signing" features portraits of leaders like Jefferson and Franklin, while center stage in "Swearing" is occupied by the new citizen (whose upraised hand also echoes the grand gesture of Columbus). The *Duluth Herald* spelled out the lesson: "Ericson has succeeded in giving to the feature of the central figure in this mural enough determination, reverence and knowledge of responsibility to influence the thoughts of any young man considering the step of citizenship."[13]

The final pairing offers the most dynamic images, and is the most mythic. Powerful animals lead the compositions of "Lumbering in Minnesota" and "Westward Ho" across rolling landscapes. A four-horse team pulls a massive load of logs out of the snowy woods while oxen draw a wagon train, a familiar symbol of civilization's progress, over "the fertile plains of southern and western Minnesota."[14] Period critics noted Ericson's forceful portrayals of the working beasts (which indeed show at least as much personality as his humans) as a testimony to his studies in Paris with the animalier Emmanuel Frémiet.[15] In the common code of mural rhetoric, men (here in the guise of a sturdy logger) wrestle natural resources from the land, clearing the way for women (here in the presence of a mother and child driving the lead wagon) to bring homes and families. The theme of the paintings, and of Ericson's mural cycle as a whole, is an evolution toward Euroamerican culture summarized by art historian Bailey Van Hook: "When the settlement of the West took the form of a series of panels, the artists implied that the progression was the order of things."[16]

Ericson's subjects have familiar precedents in American public art. The United States Capitol in Washington, D. C. was the site of 19th century forays into mural painting that were already touchstones of national iconography in Ericson's time: John Trumbull's "Declaration of Independence" mural of 1817 – 19, John Vanderlyn's "Landing of Columbus" of 1836 – 37, and Emmanuel Leutze's "Westward the Course of Empire Takes its Way" of 1862. Similar mural themes were chosen for widely publicized state capitols and other public structures during a civic building boom in the decades around 1900. Countless historical illustrations, often reproduced in color, appeared in newspapers, books, and especially the magazines that proliferated in the new century. Ericson's paintings may be seen as variations on those themes and approaches, as well as a point on the continuum of American public art.

The Hibbing commission came at the end of a "Golden Age" for American mural painting dating back to the lavishly ornamented walls of the 1893 World's Columbian Exposition and the Library of Congress. Closer to home, Minnesotans encountered the work of the nation's leading muralists in the Minnesota State Capitol in St. Paul. There architect Cass Gilbert had not only contracted with painters like John LaFarge and Edwin H. Blashfield, but had also accommodated public taste by shifting the ideological thrust of the mural program from allegories of civic virtue to historic scenes with local content.[17] Minnesota courthouses, schools and libraries from Winona to the Iron Range were subsequently

Lumbering in Minnesota (top)
Westward Ho (bottom)
oil on canvas, 1922 – 1923, 68" x 77" each

decorated with representations of Liberty and workers,
Wisdom and local history. Hibbing itself had earlier exam-
ples of the genre: Duluth artist Clarence C. Rosencranz
painted allegorical compositions in 1917 for the city library,
while David Workman painted the iron industry in a 47-
foot-long opus. A subject that is conspicuously absent from
Ericson's mural cycle, the iron industry and its international
workforce are dramatically depicted from mines to mill in
Workman's 1913 painting. Commissioned originally for
Lincoln High School in North Hibbing, it was moved to the
library of the new school where its gritty detail complements
Ericson's more genteel treatment of local history.

The Hibbing High School mural cycle was a notable exercise
in decorating a public building with meaningful artworks.
Responding to an architectural setting and an interpretive
agenda, Ericson proved himself more than "a figure of
technical competence," as J. Gray Sweeney identified his
achievement at its most basic level.[18] Ericson demonstrated
versatility in adapting his signature tonal style to a mural
commission. He marshaled a subtle skill in illustrating the
required subject matter. Eschewing fussy detail and pedes-
trian narration in favor of a treatment that invited the play
of associations, Ericson's work achieved the kind of balance
sought for mural commissions nationwide: "In avoiding
literalism, [mural paintings] seemed somewhat unexpectedly
'modern.' Their sense of timelessness was also future-ori-
ented despite reliance on historical symbolism."[19]

On completion of his pictorial tribute to America, Ericson,
the foreign-born son of a naturalized citizen, used his fee
to leave the country for an extended European stay. Just
months after the installation of the Hibbing murals, his
work was attracting attention and praise in France.[20] He
would remain there until the outbreak of World War II,
refining his easel paintings in ways only modestly touched
by modern movements. Ericson missed the next chapter in
American mural history during his long time abroad, as
the federal government commissioned paintings for public
buildings through several New Deal programs of the
1930s. In the final year of his life he executed a last large

commission in Gary, on the western edge of Duluth, where he painted 24 saints for the altar screen of St. George Serbian Orthodox Church.[21]

Ericson's Hibbing High School murals stand as a high point in a career marked by professionalism, versatility, and commitment to a mode of painting that celebrated the sense of reverie he found in moonlit waters and historical musings.

[1] William Watts Folwell, *A History of Minnesota*, rev. ed. (St. Paul: Minnesota Historical Society,1969), IV, 51.

[2] "The Schools of Hibbing and Independent School District Number Twenty-Seven," (Hibbing: publisher unknown, 1926), unpaged.

[3] Folwell, IV, 52. A summary of the development of Hibbing, including its move and dealings with the Oliver Iron Mining Company, is in Arnold R. Alanen, "Years of Change on the Iron Range" in Clifford E. Clark, Jr. (ed.), *Minnesota in a Century of Change: The State and its People Since 1900* (St. Paul: Minnesota Historical Society Press, 1989), 165.

[4] David Gebhard and Tom Martinson, *A Guide to the Architecture of Minnesota* (Minneapolis: University of Minnesota Press, 1977), 204; "National Register of Historic Places Inventory-Nomination Form: Hibbing High School," State Historic Preservation Office, Minnesota Historical Society, 1979.

[5] "Richest Gem in Minnesota's Educational Crown to be Dedicated Today," *Duluth Herald*, January 28, 1924, 2; Dan Bergan, "The Hibbing High School" (Hibbing: *Manney's Shopper*, 2001), 6, 12. Some sources list the auditorium seating capacity as 1,822 or 1,846. Bergan and oral sources credit the Capitol Theatre in New York City as the model for the auditorium; photographs show the theatre, which is no longer extant, to have been similarly rich in décor but different in design.

[6] "Famous Paintings of David Erickson [sic], Who Will Execute Mural Panels for New High School, to be Placed on Display in Hibbing, it is Said," *Hibbing Daily News* and *The Mesaba Ore*, November 22, 1922, 1.

[7] Patricia M. Burnham and Lucretia Hoover Griese, eds., *Redefining American History Painting* (New York: Cambridge University Press, 1995), 11.

[8] "The Schools of Hibbing . . ."

[9] Lula Merrick, "The Art of David Ericson," *International Studio*, February 1924, 419.

[10] Dorothy Gees Seckler, "History of the Provincetown Art Colony" in Ronald A. Kuchta, ed., *Provincetown Painters* (Syracuse NY: Everson Museum of Art, 1977), 25.

[11] J. Gray Sweeney, *American Painting at the Tweed Museum of Art and Glensheen* (Duluth MN: Tweed Museum of Art, 1982), 194-196.

[12] "Warm tribute paid to the genius of David Ericson and his murals for the new Hibbing High School, by New York Critic," *Duluth Herald*, January 18, 1924, 1.

[13] Ibid.

[14] "Famous Paintings of David Ericson . . ."

[15] Merrick, 420; "Warm tribute . . . ;" for Frémiet, see Robert Rosenblum and H. W. Janson, *19th-Century Art* (New York: Harry N. Abrams, Inc., 1984), 467-8.

[16] Bailey Van Hook, *The Virgin and the Dynamo: Public Murals in American Architecture, 1893-1917* (Athen OH: Ohio University Press), 174.

[17] Thomas O'Sullivan, *North Star Statehouse: An Armchair Guide to the Minnesota State Capitol* (St. Paul: Pogo Press, 1994), 75-80; Sally Webster, "The Civilization of the West" in Barbara S. Christen and Steven Flanders, *Cass Gilbert, Life and Work: Architect of the Public Domain* (New York: W. W. Norton and Company, 2001), 110.

[18] Sweeney, 200.

Swearing Allegiance to the United States (top)
Signing of the Declaration of Independence (bottom)
oil on canvas, 1922 – 1923, 68" x 77" each

[19] H. Wayne Morgan, *New Muses: Art in American Culture*, 1865-1920 (Norman: Oklahoma University Press, 1978), 54.

[20] The June 10, 1924 article in *Revue de Vrai et Beau* is quoted in William G. Boyce, David Ericson (Duluth: University of Minnesota, 1963), 9.

[21] Earl Finberg, "Ericson: Duluth's Revered Painter," *Duluth News-Tribune*, July 21, 1946, 12-13.

BIOGRAPHY OF A DULUTH CULTURAL ICON

by Peter Spooner

In rediscovering the artist David Axel Ericson, we celebrate the extraordinary talent of a poor immigrant, a sickly local-boy-made-good who rose to become the cultural icon in the field of visual art for northern Minnesota at the end of the 19th century. Having endeared himself to Duluth's leading citizens, Ericson went on to study abroad and to paint in Europe's art capitals with their support. The developing artist returned to the place of his childhood again and again, to grace the homes of his benefactors and its public spaces with his canvases, and to share his knowledge in teaching right up until his death in 1946. The series of events that inspired Ericson to pursue a career as a painter took place during his childhood in Duluth, and even years later continued to have a profound effect on his art. A review of his early biography is not just scene-setting but a way of better understanding why, how, and what he chose to paint.

David's father, Karl Erik Wilhelm Eriksson, arrived in Duluth in 1872, on the heels of the mass immigration of 60,000 Swedish citizens, spurred by several starvation years due to crop failures in their homeland. Eriksson came from Motala, on the Gota Canal in Ostergotland Province in southeastern Sweden, where he was a laborer and blacksmith's helper and where, in 1869, David Axel Ericson (the family name was anglicized on their arrival) was born. In 1873, the family was living in Duluth and included David's mother, Augusta Engman Eriksson (1832 – 1905), his maternal grandmother, and siblings Charles, Alfred, Josephine, and the infant Enoch (ages 12, 10, 7 and 1, respectively). A sister, Victoria, was born in 1875. Life had been difficult in Sweden, and it was not much easier for Karl Ericson, an absentee alcoholic itinerant farm worker, to support his large family in a sparsely settled and frontier-like 1870s Duluth.

The young Ericson had a keen interest in animals and nature and observational skills that later contributed to his developing draftsmanship. Accounts of Ericson's early childhood tell of him selling a portrait of his grandmother to the family grocer for a quarter, cutting intricate scenes out of paper, and modeling figures from the red clay so abundant around Duluth. At age 8, David developed an infection in his right knee, and was forced to use crutches. He was unable to walk, and was completely bedridden for two years before the leg was finally amputated when he was eleven. Such an extended illness would necessarily separate the boy from the normal physical pursuits of childhood. Confined to the indoors, a witness to other childrens play and the activity of the busy harbor, he would have to create another life, and dreams of his future, through his imagination. It was during this period of illness that Ericson's pursuit of art seemed to lead to a serious career.

In eulogizing Ericson, the Reverend Homer Anderson mused, "...here was a boy who never knew defeat; who took the shadows of darkness cast about him and wove them into silhouettes of loveliness and beauty. … In the evenings alone in his bed, he watched the illusive shadows of the fading light play across his room—and so in his imagination, saw pictures he would some day draw and paint. Of a truth, in darkness he found light and through his pain he saw beauty."[1] Though speculative, a typewritten manuscript found among the effects of Julia Romano recounts: "…sometimes David would wriggle out of bed and crawl to the window. …on the hillside were the…houses all lighted by a silvery moon, the evening star gleaming in the dark sky. Life became a romance, the houses were temples and the scene an enchantment. The years in bed brought a gradual weakness, and finally David submitted to an operation for the amputation of his leg. The recovery of health and strength – how wonderful life was, the joyfulness, the exuberance of new blood!"[2] To these mythic accounts one might add that Ericson's demonstrable artistic interests were inclined to tend toward 19th century romanticism as opposed to the developing modernist analytical movements in art. To speculate further one might consider that the artist's aesthetic was molded more by his life experiences, as well as the interests of those that encouraged and supported him rather than subsequent technical instruction or exposure to modern art.

Ericson's earliest surviving work, *Superior Street, Duluth*, is dated 1882, when he was 13 years old. The

only other work extant from this very early period is *Spirit Lake*, a water-color of a sailboat executed in a similar adolescent manner. Despite its somewhat awkward style, *Spirit Lake* presages Ericson's later obsession with water and sky as subject matter. *Superior Street, Duluth* pays homage to Duluth and to his first and arguably most important patron and teacher, Emily Sargent, later Mrs. Frederic W. Paine. Surrounded by an obsessively detailed view of Duluth's main thoroughfare, Miss Sargent is shown driving west in a one-horse carriage, presumably from her home in the "suburb" of New London, toward Ericson's home on Minnesota Point, then the poorest section of town. During his years of illness, Miss Sargent and others frequently visited the young artist, bringing him food and books. Miss Sargent brought him art supplies, gave him lessons in watercolor painting, and took him to her family's home where the artist first saw original paintings (and reproductions) of important artworks by artists such as Raphael and Rosa Bonheur.

Sixty years later, Emily Sargent Paine's son Roger, a close friend of David Ericson's, received this first surviving Ericson painting from Mrs. Afton B. Hilton (nee Emiline Johnson) a friend to David and the daughter of Charles F. Johnson, another important patron of the artist. Roger wrote to Mrs. Hilton, "I really can't tell you how delighted both Anna and I are to have David Ericson's 'Duluth in 1882'. …It seems to be so intimately connected with Mother's [Emily Sargent's] early life in Duluth. It is about that year that David lost his leg while living in the house on the point. Mother [Emily Sargent] was present and though no one else could bear to touch David's amputated leg, she went out herself and buried it in the sand. …Anna and I are very fond of Mr. Ericson and will treasure it as one of his first paintings."[3]

Immediately after the amputation of his leg, Ericson regained health and mobility. He earned a reputation as a local portraitist, sold his cut paper designs, and with the encouragement of his mother and siblings continued to study and draw from nature. Even as a relatively untrained artist, his renderings of animals and of the human figure were accurate and sensitive. Over the course of his career, Ericson was Duluth's unofficial visual biographer. A veritable history of the city between 1890 – 1920 is documented in the stories of his portrait subjects, among them his patrons and benefactors (including several doctors) along with many influential Northland business and industry leaders.

Charles F. Johnson, who owned a stationery and book store and was himself an amateur painter and a writer, gave the young artist additional lessons and materials. Between 1880 and 1885, Ericson learned to paint in oils. He was awarded a gold medal from the 1885 Art Exhibition of the Minnesota State Fair, for a work titled *Salting the Sheep*. The painting depicts his father at farm chores, a subject repeated at least ten times in his career. Competently drawn

and painted in a Barbizon-like manner, *Salting the Sheep* is also flavored with a healthy dose of adolescent literalism, presaging the sense of wistfulness and narrative pathos seen in much of his later work. The sixteen-year-old Ericson positioned a "black sheep" slightly apart from the flock. One may ask if this were to represent his absent father? Or did it symbolize the young artist himself, a teenage amputee with artistic aspirations? Ericson's other paintings of this subject, including a version painted as late as the 1920s, feature a lone sheepherder and a similarly errant animal.

From works like *Salting the Sheep* the young artist gained his first outside recognition, convincing his family (and himself, perhaps) that he might succeed as an artist in a larger, more competitive environment. In 1887 at age 18, Ericson left Minnesota for the first time. Duluth was and would remain the site of his most consistent patronage, even in the last decade of his life providing him with commissions and teaching jobs. But obviously, opportunities for exposure to art, other artists and a market were severely limited there. "His first big honor came when he was awarded first prize for a painting exhibited at the Minnesota state fair. …After this award, friends decided Duluth was 'not big enough' for Ericson. Led by C. F. Johnson, a stationer and art devotee, and A. M. Miller, wealthy retired lumberman, his admirers arranged matters so he could go to New York."[4]

1. Excerpt from a memorial talk given at Gloria Dei Lutheran Church, Duluth on December 21, 1946, by Homer J. Armstrong, Minister, Judson Church, Minneapolis. Ericson archive, Tweed Museum of Art, University of Minnesota Duluth.

2. Excerpt from an undated typewritten manuscript, written by Julia Fulton Romano. Romano's aunt, who raised her after her mother died, was Maria Vaughan Salter, whose portrait Ericson drew in 1918. Maria's husband, Charles Cotton Salter, was the first pastor of Duluth's Pilgrim Congregational Church and founder of the Duluth Bethel and YMCA. Maria Salter was active in the church's aid societies, and was no doubt one of many who assisted the family during David's illness. Ericson archive, Tweed Museum of Art, University of Minnesota Duluth.

3. . Excerpt from a letter written by Rodney Paine to Mrs. Afton B. Hilton, dated March 15, 1942. Northeast Minnesota Historical Center, St. Louis County Historical Society, Duluth, MN.

4. "Duluth Artist Realizes His Boyhood Ambitions," *Duluth Herald*, May 27, 1930.

CHRONOLOGY

1869 Born Axel David Eriksson to Karl Erik Wilhelm Eriksson and Augusta Engman Eriksson, in Motala, Ostergotland Province, Sweden. Siblings included: Charles, b. 1861; Alfred, b. 1863; Josephine, b. 1866; Enoch, b. 1872.

1872 Karl Eriksson emmigrated to America, settling in Duluth, Minnesota.

1873 Augusta Eriksson joined her husband in Duluth, along with their five children and her mother.

1875 David's sister Victoria was born in Duluth.

1878 David Ericson's brother Alfred died. Another brother, Enoch, also died as a young man.

1880 After three years of an infectious illness, David Ericson's right leg was amputated.

1880-82 Given a watercolor set and his first art lessons by Miss Emilie Sargent (Mrs. Frederic William Paine) of Duluth. At her home, he first sees original paintings and reproductions by master artists. Receives additional art materials and some drawing lessons from Mr. Charles F. Johnson of Duluth, owner of a stationery and book store.

1885 At age 16, Ericson's painting *Salting the Sheep* was awarded a gold medal at the Fine Art Exhibition of the Minnesota State Fair in St. Paul. The painting depicts his father doing farm chores.

1887-1890 With financial assistance from supportive Duluthians, Ericson began formal study at the Art Students League in New York City. He is said to have studied primarily under William Merritt Chase, Harry Mowbray, and Kenyon Cox. Records from the Art Students League indicate that Ericson was registered in the following classes: Antique Class, 1888-1889 with George Forest Brush; Sketch Class,1888-1890, instructor unknown; M (modeling?) class, 1889-1890, possibly with Augustus Saint-Gaudens; Lectures on Anatomy, 1888-1889, possibly with Thomas Eakins; 1888-1889 with J. Carroll Beckwith; Anatomy and Life Drawing, 1889, with Kenyon Cox.
 - Befriended the artists John Henry Twachtman and Edward Dufner, and the writer Stephen Crane.

1890s - Worked as an engraver for Tiffany & Co., and produced illustrations for *St. Nicholas Magazine, Life, The Century and Youth's Companion.*
 - Traveled between New York City and Duluth; produced portraits of family members and patrons in Duluth.

- In October of 1892 painted a portrait of Stephen Crane in his New York studio

1900
- Traveled to Europe, where he studied in Paris with James A. McNeill Whistler, Rene Francois Prinet, and Emmanuel Frémiet.
- Exhibits painting *Orpheus* at the Art Institute of Chicago Annual (cat. #90); in the A.I.C. Annual Record his address is listed as 52 Ave.du Maine, Paris.

1901-02 Traveled to Belgium and Italy. A letter from Ericson in Paris to Mrs. F. W. Paine in Duluth details a trip to Italy just before Easter, 1901. The same letter also mentions that he met "The famous Mr. Tanner" (Henry Ossawa Tanner), at a Salon opening.

1902 Returned to Duluth from Europe late in the year. Painted commissioned portraits.

1903
- Married Susan Barnard of Duluth. The couple moved to New York City, where they remained through 1909.
- Exhibited *Auvers by Moonlight* at the Art Institute of Chicago Annual (cat. #130); in the A.I.C. Annual Record his address is listed as 1005 E. 3rd St., Duluth, Minn.
- Received an Honorable Mention for a work exhibited in the Carnegie International, Pittsburgh
- Ericson's painting *The Spinner* was purchased for the Duluth Public Library by the Duluth Society for the Encouragement of Art (February 18, 1903)

1904
- The Ericson's only child, David Barnard Ericson, was born in New York City.
- Won a silver medal at the St. Louis Universal Exposition, for a painting titled *Pont Aven*.
- Received an Honorable Mention for a work exhibited in the Carnegie Institute International Exhibition.

1905 Ericson's mother died. In her honor, he painted an Ascension scene for the altar at Goria Dei Lutheran Church.

1908-09 Employed as an instructor at the Buffalo Art School, Buffalo, New York.

1909 Exhibited *Portrait de Mme. Ericson* at the Paris Salon. In the catalogue, he is noted as living in Etaples, Pas-de-Calais.

1910 Traveled to Europe a second time to study and paint, accompanied by his wife and son. Exhibits *L'hiver* at the Paris Salon. In the catalogue, he is noted as living at "chez M. Lucien Lefebvre-Foinet, rue Vavin, 19." Returned to Duluth by early December

1911
- Exhibitions of Ericson's work were held in St. Paul, Duluth, and Chicago
- Received First Prize in the Minnesota Art Exposition, St. Paul
- Through 1912, painted in Etaples, a small coastal village in northern France

1912
- April 8 -14, exhibits twenty paintings at the Handicraft Guild Hall, 89 South Tenth Street, Minneapolis. According to an April 7, 1912 notice in *The Minneapolis Tribune*, Ericson maintained a studio there.
- Traveled to Europe a third time, painting in Belgium, Holland, and in Devon, England.

1913 A letter from her cousin Eunice Johnson in Duluth is addressed to "Mrs. David Ericson, 107 East 27th St. New York City, New York," postmarked December.

1914
- The Ericson's returned from Europe, settling in Provincetown, Massachusetts. Taught a class at the Elverhoi Art Colony at Milton-on Hudson, New York.

Exhibited *On the Hudson* and *Winter in France* at the Art Institute of Chicago Annual (cat. #104 and 105); in the A.I.C. Annual Record his address is listed as 1960 Rondo St., St. Paul, Minn.

1915
- Taught an art class in Milton, Wisconsin.
- Exhibits *The Late Tea* and *Low Tide* at the Panama-Pacific International Exposition, San Francisco; page 112 of the catalogue lists him as "Born in Duluth, Minn."

1916-17 Lived in Duluth.

1919 Returned to Provincetown, Massachusetts, where the Ericsons purchased a home and remained through 1924, making brief trips to Duluth.

1920
- Exhibited *The Green Cape* and *Winter – Darien, Conn.* in Provincetown.
- Exhibited *Silent Night* at the Art Institute of Chicago Annual (cat. #66); in the A.I.C. Annual Record his address is listed as Provincetown, Mass.

1922-23 Painted six large murals for the Hibbing, Minnesota High School in his studio in Provincetown.

1924
- Traveled to Europe for the fourth time, accompanied by his wife and son. Through 1939 the Ericsons maintained an address in Paris, returning to the U.S. for exhibitions and brief periods of teaching.
- In February, the art journal *International Studio* publishes an article on Ericson.
- The June 10, 1924 *Revue du Vrai et Beau* publishes an article on Ericson.

1925 Exhibited *Honfleur* in the exhibition of the Societe Nationale des Beaux-Arts.

1926 Returned briefly to Duluth for an exhibition of his latest work.

1929 Painted in St. Tropez, in the south of France. Address listed as c/o American Express Co., 11 Rue Scribe, Paris.

1930
- Returned to U.S. for exhibitions in Duluth and Detroit; in late January he was in Detroit overseeing the installation of paintings shipped from France; by late May he was in Duluth for an exhibition there, and in July he painted a series of images of Lake Superior's North Shore.
- Commissioned by the Swedish-American League of Duluth to paint a portrait of Swedish botanist Karl von Linne, which was donated to Denfeld High

School in the fall of 1930. According to a March 28, 1936 *Duluth News Tribune* article, the Ericson portrait was to appear in a book of Linneus portraits being written in Sweden by a Professor Tullberg and his daughter, Landshovdingskan Ingerd Beskov.
- According to a letter from the artist to F. W. Paine in Duluth, Ericson was in Paris in September. Ericson and Heldner paint together in southern France at some point during 1931 and 1932.

1931-32 - Traveled extensively in Italy beginning in July; was in Capri in October.
- Knute Heldner, a fellow artist and Swedish immigrant who also settled in Duluth, paints Ericson's portrait in Paris, and Ericson paints Heldner's portrait.

1933 While in France, painted portrait of northern Minnesota Judge William A. Cant; the portrait was shipped to Duluth and hung in the courthouse where Cant presided.

1934 Ericson was photographed painting in Jay Cooke State Park, south of Duluth, by John H. Steele. At various times, Ericson rented a room from Steele's parents in their home on 12th Avenue in Duluth.

1934-36 Taught and painted in Duluth, which he would do again in 1943 – 46. Among his students are Dr. Arthur N. Collins, Earl DiMarco, Margaret Hunner, Mary Lyons, Frances McGiffert, Rodney Paine, James G. Nye, Brian Catlin, William Baumgarten, Anna Silverness, and Charles Ziegler.

1935 A letter to Susan Ericson from her brother Joe in Santa Barbara, California was addressed to "Mrs. D. B. Ericson, c/o American Express Co., Amagerton 25, Copenhagen, Denmark".

1937-38 David Ericson was in Paris with his wife.

1940 - Traveled to Venice with Susan; a letter from David Ericson to Rodney Paine in Duluth, confirms that they are there in February of 1940.
- David and Susan Ericson returned to Provincetown from Venice; a letter from David Ericson to Rodney Paine in Duluth, offering sympathy at the death of Paine's father Frederic, confirms that they are "getting settled" in Provincetown in April, 1940.

1941 - Susan Barnard Ericson died in Provincetown, on November 15.
- A 1941 letter to Rodney Paine states that David and his son are "living in the oldest house in town, built in 1785." The return address on other letters from this period is 23 Conant Street, Provincetown.

1942 From Provincetown, Ericson wrote a reminiscence of his association with the writer Steven Crane in New York City in the 1890s, at the request of Ames W. Williams, a noted Crane scholar and collector.

1943 - In the summer, returned to Duluth to live, teach and paint, first as the guest of his niece, Mrs. Al H. Moe, and later residing at 20 North Avenue East.
- Taught classes for the Duluth Art Institute for three years beginning in 1943.

1944 - Worked out of a studio in Tweed Hall, where Duluth State Teachers College (now University of Minnesota Duluth) then housed its Art Department.
- Commissioned to paint a series of twenty-four altar paintings for the St. George Serbian Orthodox Church, located at 1216 – 104th Avenue West, Duluth.

1946 On December 5th, Ericson was hit by a car at 12th Avenue East and Superior Street in Duluth. He died on December 14th as a result of his injuries. Funeral services were held at Gloria Dei Lutheran Church in Duluth, where he had previously executed a large altar painting in memory of his mother. Ericson was buried in Minneapolis, where his two surviving sisters then lived.

1950 Ten Ericson paintings were exhibited in the Centennial Section of the Minnesota State Fair Fine Arts Exhibit, organized by Clement Haupers, with the cooperation of Dell (Della H.) Wheeler of Duluth, who continued to exhibit and sell Ericson's work after his death.

1963 William G. Boyce, Director of the Tweed Museum of Art at the University of Minnesota Duluth, curated the first major posthumous exhibition, featuring over one-hundred paintings by Ericson. A small catalogue is published.

1965 Exhibition of 28 David Ericson paintings at the Swedish-American Institute, Minneapolis, September and October. Thirteen works were lent from the collection of the Tweed Museum of Art, along with an additional fifteen which were on extended loan to the museum from the artist's son.

1982 A substantial entry on the artist was published in *American Paintings: Tweed Museum of Art*, researched and written by J. Gray Sweeney, and published by the Tweed Museum of Art, University of Minnesota Duluth.

2005 Nearly sixty years after his death, the Tweed Museum of Art publishes the first monograph on the artist and organizes the first major exhibition of his work in over forty years.

Misty Morning, 1920
oil on Canvas, 40" x 39"
Tweed Museum of Art
Gift of William & Mabel Stephenson

EXHIBITIONS

1885 *Fine Arts Exhibition.* Minnesota State Fair, St. Paul; awarded a Gold Medal for painting *Salting the Sheep.*

1900 *Annual Exhibition.* Art Institute of Chicago Annual, exhibited *Orpheus,* cat. #90

1903 *Annual Exhibition.* Art Institute of Chicago, exhibited *Auvers by Moonlight,* cat. #130
International Exhibition. Carnegie Institute, Pittsburgh, PA, receives Honorable Mention.

1904 *Universal Exposition.* Department of Art, St. Louis, exhibited *Pont Aven,* cat. #237

1909 *Paris Salon.* Bibliotheque des Annales, Paris, exhibited *Portrait de Mme. Ericson,* cat. #643

1910 *Paris Salon.* Bibliotheque des Annales, Paris, exhibited *L'hiver,* cat. #724

1911 *Minnesota Art Exposition.* St. Paul, First Prize
Solo exhibitions in Duluth and Chicago.

1912 Solo exhibition of 20 paintings at Handicraft Guild, 89 South Tenth Street, Minneapolis

1914 *Annual Exhibition.* Art Institute of Chicago, exhibited *On the Hudson* and *Winter in France,* cat. #104, 105

1915 *Panama-Pacific International Exposition.* Department of Fine Arts, San Francisco, exhibited *The Late Tea* and *Low Tide,* cat. #2110 and 4434

1920 *Annual Exhibition.* Art Institute of Chicago, exhibited *Silent Night,* cat. #66
The Society of Independent Artists, exhibited *The Green Cape* and *Winter – Darien, Conn.* cat. #228, 229;

1924 McKindley Galleries, Duluth, MN, December

1925 *Societe Nationale des Beaux-Arts.* Paris, exhibited *Honfleur,* cat. #149

1926 *Paris Salon.* Bibliotheque des Annales, Paris, exhibited bronze sculpture

Two Boys (The Sailing of Ships), ca. 1910 – 1915
watercolor on paper mounted on board, 20" x 25"
Tweed Museum of Art,
Gift of the Estate of Theresa M. Wood

Indians on Horseback
Solo Exhibition. Duluth Art Association, Duluth,
MN, May 8-22

1942 *David Ericson in Retrospect.* Solo exhibition, Duluth
 Art Center, October

1950 Centennial Section, Minnesota State Fair, St.
 Paul; ten Ericson paintings are exhibited.
 Organized by Clement Haupers with the
 assistance of Duluth art dealer Della (Dell)
 Wheeler.

1953 Tweed Gallery. University of Minnesota Duluth,
 April

1963 *David Ericson.* Tweed Museum of Art, University
 of Minnesota Duluth, curated by William G.
 Boyce; one-hundred eleven works are exhibited,
 a small catalogue is published.

1965 Solo exhibition of 28 works at Swedish-
 American Institute, Minneapolis, MN

1984 *David Ericson and Knute Heldner.* Tweed Museum of
 Art, University of Minnesota Duluth,
 July 17 - August 27

1994 *Art and Life on the Upper Mississippi*, 1890-1915.
 Minneapolis Institute of Arts, exhibited Ericson's
 Morning of Life

1996 *Minnesota Impressionists.* Tweed Museum of Art,
 University of Minnesota Duluth, co-curated by
 Rena Coen and Peter F. Spooner

2005 *David Ericson, Always Returning:The Life and Work of a
 Duluth Cultural Icon.* Tweed Museum of Art,
 University of Minnesota Duluth, curated by Peter
 F. Spooner, accompanied by the first monograph
 on the artist

BIBLIOGRAPHY

1904 "More Honors For David Ericson". *Duluth News Tribune/Duluth Herald*,
 November 29
 Catalogue of Exhibits. Department of Art, Universal Exposition, St. Louis, #237

1909 Catalogue of the Salon de 1909. Ludovic Baschet, Director, Bibliotheque des
 Annales, Paris; #643

1910 "Artist Who Will Paint Portrait In Oil Of Ex-Mayor Henry Truelsen".
 (photograph of David Ericson) *Duluth Herald*, April 14
 Catalogue of the Salon de 1910, Edition Baschet, Bibliotheque des Annales,
 Paris; #724

1911 "A Duluth Artist and His Splendid Work". *Duluth News Tribune*, October 29

1912 "Work of Minnesota Artist, David Ericson, Who Enjoys an International
 Reputation". *The Minneapolis Sunday Tribune*, March 3, p. 24

1914 Allgeneines Lexicon de Bildneden Kunstler. Ulrich Thieme, Liepzig, Germany, 602.

1915 Catalogue. Department of Fine Arts, Panama-Pacific International Exposition,
 San Francisco, #2110, #4434.

1918 *American Art Annual*, vol. X, p. 255

1924 "Warm Tribute Paid to the Genius of David Ericson and his Murals for the
 New Hibbing High School, by New York Critic". *Duluth Herald*, January 18
 Merrick, Lula. *International Studio*, February
 Revue du Vrai et Beau, June 10
 "Mrs. McKindley Receives from France Works of David Ericson". *Duluth News
 Tribune*, December 15

1925 Catalogue of Painting, Sculpture, Design, Architecture and Decorative Art.
 Exhibition of the Societe Nationale des Beaux-Arts, #149.

1926 "Encouragement of Artists Urged by David Ericson". *Duluth News Tribune*,
 May 8
 "Ericson Displays Prowess As Sculptor As Well As In Painting". *Duluth News
 Tribune*, May 14

1927 "Ericson Exhibition Will Include Many of Latest Pictures". *Duluth News Tribune*, October 26

1930 "Artist Comes Home to Duluth as World Praises His Work". *The Minneapolis Tribune*, May 24
"Duluth Artist Realizes His Boyhood Ambitions". *Duluth Herald*, May 27
"School's Collection Grows: Denfeld Gets Work By Duluth Artist". *Duluth Herald*, July 27

1932 "Artists Paint Portraits of Each Other". *Minneapolis Tribune*, May 4

1936 Cohen, Nathan. "The Palette and Brush for Relaxation: Duluth's Business and Professional Men Turn to Art as Hobby". *Duluth Herald*, May 31

1946 Fineberg, Earl. "Ericson: Duluth's Revered Painter". *Duluth News Tribune*, July 21
"Inquest Decision Due in Ericson Death". *Duluth Herald*, December 16, p. 11
"David Ericson, Noted Duluth Artist, Dies of Car Injuries". *Duluth Herald*, December 16

1953 "Ericson Exhibition Opens". *Duluth News Tribune*, April 12

1963 Boyce, William G. *David Ericson*. Duluth, MN: Tweed Museum of Art, University of Minnesota Duluth (exhibition catalogue)
"Ericson Display Slated at UMD". *Duluth News Tribune*, September 29

1982 Sweeney, J. Gray. *American Paintings: Tweed Museum of Art*. Tweed Museum of Art, University of Minnesota Duluth, pp. 188-201

1984 Aschenmacher, Bob. "Meet Two of Duluth's Best Painters". *Duluth News Tribune*, July 15

1994 O'Sullivan, Thomas. "Robert Koehler and Painting in Minnesota," in *Art and Life on the Upper Mississippi, 1890-1915*. Michael Conforti, ed., Newark, NJ: University of Delaware Press 1994

1996 Coen, Rena Neumann. *Minnesota Impressionists*. Afton, MN: Afton Historical Society Press, pp. 37 – 40
Marlor, Clark S. *The Society of Independent Artists*. The Exhibition Record 1917-1944, Park Ridge, NY: Noyes Press, p. 229

1997 "Bookworks: An Excerpt from *Minnesota Impressionists*". *NorthLife*, August

2005 Patricia Maus, Thomas O'Sullivan, and Peter Spooner. *David Ericson, Always Returning: The Life and Work of a Duluth Cultural Icon*. Duluth, MN: Tweed Museum of Art, University of Minnesota Duluth (exhibition catalogue)

PAINTINGS

Superior Street, Duluth, 1882
watercolor on paper, 5" x12"
Collection of St. Louis County Historical Society, Duluth

Spirit Lake, ca. 1880s
watercolor on paper, 8" x 13"
Collection of Neal and Kathy Hesson

Salting the Sheep, 1885
oil on canvas, 30 ¼" x 40"
Tweed Museum of Art, Gift of the Estate of Mrs. A. M. Miller

Portrait of Stephen Crane, 1892 (6-20-92)
oil on board, 11" x 7"
Tweed Museum of Art, Gift of Dr. David B. Ericson

Portrait of Charles F. Johnson, 1896
oil on canvas on board, 8" x 6"
Collection of St. Louis County Historical Society, Duluth
(On verso is painting sketch "Orpheus")

Marshland, 1898
watercolor on paper, 6 ⅜" x 10"
Tweed Museum of Art, Gift of Miss Virginia McDonald

Portrait of the Artist's Mother, ca. 1890 – 1900
oil on canvas, 10" x 8"
Tweed Museum of Art, Gift of Mrs. C. M. Brewster

Portrait of the Artist's Sister, Victoria, ca. 1900 – 1905
oil on canvas, 15" x 13"
Tweed Museum of Art, Gift of Mrs. C. M. Brewster

Portrait of the Artist's Brother, Charlie, 1902
oil on canvas, 16" x 13"
Tweed Museum of Art, Gift of Gerald B. Thoreson

Sheepherder, 1903
oil on canvas, 22" x 30"
Tweed Museum of Art, Gift of the Estate of George H. Crosby

The Spinner (Pont Aven, France), ca. 1900 – 1903
oil on canvas, 29" x 30"
Collection of Duluth Public Library, City of Duluth

Graveyard Sermon, ca. 1900 – 1910
oil on canvas board, 8 ⅛" x 11"
Tweed Museum of Art, Gift of Mr. Howard W. Lyon

Blue Landscape with Nymphs Dancing, ca. 1900 – 1910
oil on canvas, 30" x 38 ⅛"
Tweed Museum of Art, Gift of Mr. and Mrs. C. M. Heimbach

The Sheik, ca. 1900 – 1910
oil on canvas, 22" x 18"
An Anonymous Private Collection

Morning of Life, 1907
oil on canvas, 27" x 22 ¼"
Tweed Museum of Art, Gift of Mrs. E. L. Tuohy

Boy with Toy Sailboat, ca. 1910 – 1912
oil on canvas, 36 ¼" x 27 ⅝"
Tweed Museum of Art, Gift of Dr. David B. Ericson

The Artist's Son, France, 1910
oil on canvas, 21" x 18"
Collection of Kevin Owens

Coast of Brittany, 1910
oil on canvas, 28" x 36"
Tweed Museum of Art, Gift of Mrs. A. M. Chisholm

Old Church, Brittany, ca. 1910 – 1915
oil on canvas, 23" x 19"
Tweed Museum of Art, Gift of Dr. Robert J. Goldish

Two Boys (The Sailing of Ships), ca. 1910 – 1915
watercolor on paper mounted on board, 20" x 25"
Tweed Museum of Art,
Gift of the Estate of Theresa M. Wood

Shepherd and Sheep, ca. 1910 – 1920
oil on canvas, 16" x 20"
Collection of Joanne Halsey

Nativity, ca. 1910 – 1919
oil on canvas, 86" x 60"
Tweed Museum of Art,
Alice Tweed Tuohy Foundation Purchase Fund

Portrait of Captain Marcus L. Fay, 1911
oil on canvas, 36" x 27"
Tweed Museum of Art, Gift of Mr. Ralph H. Schulze

Portrait of Mrs. Marcus L. Fay, ca. 1911
oil on canvas, 36" x 27"
Tweed Museum of Art, Gift of Mr. Ralph H. Schulze

Bruges, Belgium, ca. 1912 – 1914
oil on canvas, 21 ⅝" x 17 ⅞"
Collection of Glensheen Historic Estate,
University of Minnesota Duluth

French Village Scene, ca. 1912 – 1914
oil on board, 5½" x 8"
Tweed Museum of Art,
Gift of the Estate of Bernice T. Brickson

Village Scene, Evening, ca. 1912 – 1914
oil on canvas, 9" x 10 ½"
Tweed Museum of Art,
Gift of the Estate of Bernice T. Brickson

French Harbor Scene with Boats, ca. 1912 – 1914
oil on canvas, 7" x 9"
Tweed Museum of Art,
Gift of the Estate of Bernice T. Brickson

French Beach Scene, ca. 1912 – 1914
oil on board, 7" x 9"
Tweed Museum of Art, Gift of the Estate of Bernice T. Brickson

French Village Scene, ca. 1912 – 1914
oil on board, 5 ½" x 8"
Tweed Museum of Art, Gift of the Estate of Bernice T. Brickson

Etaples, France (Landscape in Blue and Gray), ca. 1912 – 1914
oil on wood, 9 ¾" x 12"
Collection of Tweed Museum of Art, Gift of Mrs. C.M. Brewster

Moonlight, Etaples, France, ca. 1912 – 1914
oil on composition board, 7 ⅝" x 5"
Tweed Museum of Art, Gift of Mrs. E. L. Tuohy

Untitled (Impressionist Landscape with House), 1914
oil on canvas, 30" x 35"
Collection of Anne Aspoas

The Green House at Elverhoi, ca. 1914
oil on canvas, 40 ⅜" x 40 ⅜"
Tweed Museum of Art, Gift of Dr. David B. Ericson

Untitled (Winter Scene with Sheepherder), ca. 1915 – 1925
oil on canvas, 28 ⅝" x 23"
Collection of Neal and Kathy Hesson

Sailing Ship, ca. 1920s
oil on canvas, 32" x 36"
Tweed Museum of Art, Gift of Mrs. A. Y. Peterson

Untitled (Seascape with Sailboats, Primel Tivistere), ca. 1920s
oil on canvas, approx. 23 ⅝" x 28 ⅞"
Collection of Margaret Jost

Fruit (Still Life), ca. 1915 – 1925
oil on canvas, 23 ⅝" x 23 ¼"
Tweed Museum of Art, Gift of Dr. David B. Ericson

By Lamplight, 1920
oil on canvas, 40" x 35"
Tweed Museum of Art, Gift of Dr. David B. Ericson

Misty Morning, 1920
oil on Canvas, 40" x 39"
Tweed Museum of Art,
Gift of William & Mabel Stephenson

Marketplace, 1921
oil on canvas, 21" x 25"
Tweed Museum of Art, Gift of Dr. and Mrs. Albert Tezla

Woman at Dressing Table, ca, 1920 – 1930
oil on canvas, 26" x 26"
Tweed Museum of Art, Gift of Catherine Boynton

The Green Cape, ca. 1920s
oil on canvas, 40" x 40"
Tweed Museum of Art, Gift of Dr. David B. Ericson

Brittany Fair (Marketplace), ca. 1920s
oil on canvas, 21 ¾" x 26"
Tweed Museum of Art, Gift of Theresa M. Wood Estate

White Clouds (The Brittany Road), ca. 1920s
oil on canvas, 25 ¾" x 31 ¾"
Tweed Museum of Art, Gift of Theresa M. Wood Estate

Looking Across the Seine, ca. 1920s
oil on wood panel, 10 ½" x 13 ¾"
Tweed Museum of Art, Gift of David Prudden

Interior, Gorches, ca. 1920s
oil on canvas, 25" x 21 ⅛"
Collection of Beverly Goldfine

Fisherman's Cottages (Early Moon-rise), ca. 1915 – 1924
oil on canvas, 24" x 30"
Collection of Joanne Halsey

Path Between Blue Trees, 1925
oil on canvas, 25 ⅝" x 17 ⅛"
Tweed Museum of Art, Gift of the Estate of Julia Romano

Alps Maritime, 1925
oil on canvas, 25 ⅝" x 32"
Tweed Museum of Art, Gift of Dr. David B. Ericson

Mountain Town, ca. 1925
oil on canvas, 25" x 19"
Tweed Museum of Art, Gift of Dr. David B. Ericson

Untitled (Plowing), ca. 1925
oil on canvas, 30" x 40"
Tweed Museum of Art, Gift of Mrs. Frances E. Getzen

Woman in Black Coat, ca.1925 – 1935
oil on canvas, 45" x 35"
Tweed Museum of Art, Gift of Dr. David B. Ericson

Moonlight Marine (Moonlight), 1926
oil on canvas, 23 ¾" x 28 ¾"
Tweed Museum of Art,
Gift of the Estate of Theresa M. Wood

Portals of the Past, 1926
oil on panel with carved frame, 21" x 35 ⅛" x 2"
Tweed Museum of Art,
Gift of the Nat G. Polinsky Rehabilitation Center

Portrait of Gladys Congalton, 1926
oil on canvas, 30" x 28"
Tweed Museum of Art, Gift of Mrs. Gladys Congalton

Night and Day, ca. 1925 – 1935
oil on canvas, 32" x 40"
Collection of Tiss Underdahl

Old Tidal Mill, Plumanac'h, Brittany, France, ca. 1926
oil on canvas, 13" x 16 ¼"
Tweed Museum of Art,
Gift of Mrs. C.M. Brewster

Daniel De Gresolon, Sieur Dulhut of the Royal Guard of Louis XIV,
at Saint-Germaine-en-Lays, on the Seine, ca.1920 – 1930
oil on canvas, 46" x 57"
Collection of St. Louis County Historical Society, Duluth

Winter Mists (Winter Scene, France), ca. 1925 – 1935
oil on canvas, 51" x 52"
Collection of Robert M. and Mary Ellen Owens

Fields, 1927
oil on canvas, 38" x 40"
Tweed Museum of Art, Gift of Dr. David B. Ericson

Untitled (Cows at Market, Brittany), 1927
watercolor on paper, 13 ¾" x 16 ¾"
Collection of Elizabeth Jeronimus Estate

Untitled (Cows at Market, Brittany), ca. 1927
watercolor on paper, 13 ¾" x 16 ¾"
Collection of Elizabeth Jeronimus Estate

Village Scene (Morlaix, France), 1928
oil on canvas, 32" x 32"
Tweed Museum of Art, Gift of Mary M. Roberts

Honfleur-Street Scene, 1929
oil on canvas, 27" x 22 ⅝"
Collection of Tweed Museum of Art, Gift of Dr. David B. Ericson

Portrait of Knute Heldner, 1931
oil on canvas, 30" x 24"
Tweed Museum of Art, Gift of Major General O. J. Daigle, Jr.

Evening Star, ca. 1930s
oil on canvas, 40" x 40"
Tweed Museum of Art, Gift of Dr. David B. Ericson

Knute Heldner (American, b. Sweden, 1886 – 1952)
Portrait of David Ericson, 1931
oil on canvas 32 ½" x 25 ½"
Tweed Museum of Art
Gift of Mrs. George P. Tweed

David Ericson
Portrait of Knute Heldner, 1931
oil on canvas, 30" x 24"
Tweed Museum of Art, Gift of Major General O. J. Daigle, Jr.

St. Mark's Door in Moonlight, ca. 1930s
oil on canvas, 36" x 28"
Tweed Museum of Art, Gift of Dr. David B. Ericson

Chiesa Della Salute, ca. 1930s
oil on canvas, 31 ¾" x 31 ¾"
Tweed Museum of Art, Gift of Dr. David B. Ericson

Old Palace in the Moonlight, ca. 1930s
oil on canvas, 31 ¾" x 31 ¾"
Tweed Museum of Art, Gift of Dr. David B. Ericson

Ponte Della Calcina, ca.1930s
oil on canvas, 32" x 32"
Tweed Museum of Art, Gift of Dr. David B. Ericson

Old Bridge, Chioggia, ca. 1930s
oil on canvas, 32" x 32"
Collection of Dan and Chris King

Val Andre (Brittany, France), ca. 1930s
oil on canvas, 25 ½" x 31 ¾"
Collection of Elizabeth Jeronimus Estate

Portrait of John Henry Darling, 1935
oil on canvas, 34" x 26"
Tweed Museum of Art,
Transferred from Duluth State Teachers College

Circus, ca. 1935
oil on canvas, 34 ⅛" x 30"
Tweed Museum of Art, Gift of Dr. David B. Ericson

Portrait of Eugene William Bohannon, 1936
oil on canvas, 36" x 30"
Tweed Museum of Art,
Transferred from State Duluth Teachers College

Portrait of Eugene F. W. (Frederic William) Paine, 1937
oil on canvas, 36" x 32"
Collection of Kitchi Gammi Club, Duluth

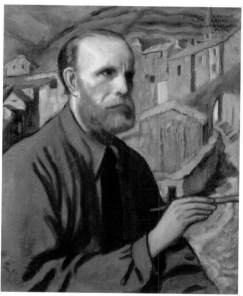

Boujital sur Seine, 1938
oil on canvas, 24" x 32"
Collection of R. Craft and Eleanore Dryer

Fishing Boats at Rest, 1938
oil on canvas, 31" x 25"
Collection of Dr. William Rudie

New Orleans, ca. 1935 – 1940
oil on board, 30" x 25"
Collection of Glensheen Historic Estate,
University of Minnesota Duluth

Tucson, Arizona Garden, 1943
oil on canvas board, 22" x 28"
Collection of Glensheen Historic Estate,
University of Minnesota Duluth

DRAWINGS, PRINTS, SCULPTURE

Girl with Cat, 1888
graphite on paper, 7" x 6"
Tweed Museum of Art, Gift of Dr. David B. Ericson

Portrait of Dr. Albert Schildt, 1897
pencil on paper, 5" x 5"
Collection of St. Louis County Historical Society, Duluth

Untitled (Male Nude), ca. 1890s
graphite on paper, 5 ³⁄₈" x 8 ⁵⁄₈"
Tweed Museum of Art, Gift of Dr. David B. Ericson

Sketchbook, ca. 1900 – 1910
44 bound sheets, various pencil
and charcoal studies, 6 ⁵⁄₈" x 10"
Tweed Museum of Art, Sax Purchase Fund

Self Portrait Sketch, ca. 1910 – 1920
ink on paper, 10" x 12"
Tweed Museum of Art, Gift of Dr. David B. Ericson
(opposite page, bottom)

Portrait of Maria (Mrs.Charles Cotton) Salter, 1918
conté crayon on paper, 17" x 12"
Tweed Museum of Art,
Gift of the Estate of Julia Romano

Untitled (Figures at Market), ca. 1920s
charcoal on paper, 6" x 9"
Tweed Museum of Art, Gift of Dr. David B. Ericson

Nude Study, ca. 1920s
conté crayon on paper, 13 ⁷⁄₈" x 9 ⁷⁄₈"
Tweed Museum of Art, Gift of Dr. David B. Ericson

Contour Drawing of Seated Female Nude, ca. 1920s
Graphite on paper, 14" x 10 ³⁄₈"
Tweed Museum of Art, Gift of Dr. David B. Ericson

Old Church in Brittany, 1925
graphite on paper, laid down on board, 10 ¹⁄₈" x 7"
Tweed Museum of Art, Gift of Stephen W. Watson

Indians on Horseback, 1925
cast bronze, 11" x 14" x 8 ½"
Tweed Museum of Art, Gift of Dr. David B. Ericson

Martiques, 1926
drypoint etching on paper, 9" x 5 ⅜"
Tweed Museum of Art, Gift of Dr. David B. Ericson

Portrait of Clara Stocker, 1927
conté crayon on paper,
Collection of St. Louis County
Historical Society, Duluth

Nude (Paris), 1927
pastel on brown paper, 12 ⅜" x 9 ⅞"
Tweed Museum of Art,
Gift of Dr. Daniel and Della Wheeler

Horse and Cart, ca. 1930s
graphite on paper, 4 ½" x 6 ½"
Tweed Museum of Art,
Gift of Dr. Daniel and Della Wheeler

Four woodcut prints, ca. 1930s
Flowers in Bowl (2); *Sailboats and Birds*; *Women at Market*,
11" x 11" each
Tweed Museum of Art, Gift of Dr. David B. Ericson

House and Road, ca. 1930s
charcoal on paper, 8" x 11"
Tweed Museum of Art, Gift of Dr. David B. Ericson
(top)

Portrait of a Child, 1933
Lithograph on paper, 7 ⅞" x 7"
Tweed Museum of Art, Sax Purchase Fund

Workhorse, 1933
Lithograph on paper, 6" x 9"
Tweed Museum of Art, Gift of Dr. David B. Ericson

STAFF AND ADMIN.

University of Minnesota
Robert H. Bruininks, *President*

BOARD OF REGENTS
David Metzen, *Chair*
Anthony R. Baraga, *Vice Chair*
Clyde Allen, Jr.
Peter Bell
Frank Berman
Dallas Bohnsack
John Frobenius
William Hogan
Richard McNamara
Lakeesha Ransom
Maureen K. Reed
Patricia Simmons

University of Minnesota Duluth
Kathryn A. Martin, *Chancellor*
Vincent R. Magnuson, *Vice Chancellor for Academic Administration*
Gregory R. Fox, *Vice Chancellor for Finance and Operations*
Bruce L. Gildseth, *Vice Chancellor for Academic Support and Student Life*
William Wade, *Vice Chancellor for University Relations*
Jack Bowman, *Dean, School of Fine Arts*
Virginia Jenkins, *Chair, Department of Art*

Tweed Museum of Art Advisory Board
Jen Bertsch
Kay Biga
Deb Bolen
Jack Bowman, *Dean, School of Fine Arts*
Florence Collins
Barb Gaddie
Susan Hagstrum
Joan Hedin
Bea Levey, *Chair*
Anne Lewis
Alice B. O'Connor
Henry Roberts
Claudia Scott Welty
Mike Seyfer
Dan Shogren
Miriam Sommerness
Ex-offcio
Kathryn A. Martin, *Chancellor*
Vincent R. Magnuson, *Vice Chancellor for Academic Administration*
Ken Bloom, *Director, Tweed Museum of Art*
Patti Tolo, *Development Officer, School of Fine Arts*

Advisory Board, Directors Circle
Adu Gindy
Beverly Goldfine
Robin Seiler

111

Tweed Museum of Art Staff

Ken Bloom, *Director*
Mary Amundsen, *Security*
Will Bartsch, *Work-Study (Technical)*
Kimberlee Galka-Smith, *IMLS Education Assistant*
Susan Hudec, *Museum Educator*
Louis Jenkins, *Security*
Chong Johnson, *Security*
Steve Johnson, *Security*
Sara Moore, *Security*
Selja Ojanne, *Security*
Sandi Peterson, *Sr. Administrative Specialist*
Lisa Ryczkowski, *Graphic Designer*
Kathy Sandstedt, *Executive Administrative Specialist*
Kim Schandel, *Museum Store Manager*
Bill Shipley, *Education Outreach*
Peter F. Spooner, *Curator / Registar*
Peter Weizenegger, *Preparator / Technician*

Museum Interns, 2005

Sarah Stone
Lindy Sexton

CATALOGUE CONTRIBUTORS

PATRICIA K. MAUS was born and reared in Minnesota and has lived in Duluth since 1966. She is the administrator and archivist of the Northeast Minnesota Historical Center located in the UMD Library complex, a position she has held for 24 years. Her degree is from the UMD art department, and she is a visual artist married to a visual artist. As a young man, David Ericson won first prize for his painting at the Minnesota State Fair: coincidentally, as a young woman, a painting by Pat Maus took the same prize in 1975.

FRANCES McGIFFERT is a lifelong resident of Duluth, now 96. A graduate of Sweet Briar College, she studied at the Ecole des Beaux Arts in Fontainebleau, and in the 1930s in Duluth, with David Ericson.

THOMAS O'SULLIVAN is a curator and writer based in St. Paul, Minnesota. A native of New York City, he holds a BA in art history from Harper College of Binghamton University and an MA in museum studies from the Cooperstown Graduate Program of the State University of New York. His experience includes positions as Curator of Art of the Minnesota Historical Society (1980 – 1999) and Curator of Library Art and Exhibitions at Gould Library, Carleton College, Northfield, Minnesota (2001 – 2005). His publications include *North Star Statehouse: An Armchair Guide to the Minnesota State Capitol* (Pogo Press, 1994) and *The Prints of Adolf Dehn* (Minnesota Historical Society Press, 1985), plus features and reviews for the *St. Paul Pioneer Press* and other popular publications. His ongoing research interests are American mural painting, natural history art, and contemporary art of the region.

PETER F. SPOONER is the Curator for Tweed Museum of Art, University of Minnesota Duluth, where he curates and writes about exhibitions, and researches and cares for collections.